Photoshop 6 Cookbook

Photoshop 6 Cookbook

Published by
Silver Pixel Press®
A Tiffen® Company
21 Jet View Drive
Rochester, NY 14624 USA
www.silverpixelpress.com

ISBN 1-883403-83-9

Originally published in German as *Computer Photo* by Dieter K. Froebisch,
Holger Lindner, and Thomas Steffen
©1995 Laterna magica, Verlag Georg D.W. Callwey GmbH & Co., Munich, Germany

Updated from the English edition *Photoshop IQ*
with new text and graphics by Kate Binder

©2001 English edition, Silver Pixel Press

Design by Andrea Zocchi Design

Printed in Germany by Kösel, Kempten

Library of Congress Cataloging-in-Publication Data
Froebisch, Dieter K.
 [Computer Photo. English]
 Photoshop 6 cookbook / Dieter K. Froebisch, Holger Lindner, Thomas
Steffen; new text and graphics by Kate Binder.
 p. cm.
 ISBN 1-883403-83-9 (pbk.)
 1. Computer graphics. 2. Adobe Photoshop. I. Lindner, Holger. II. Steffen,
Thomas. III. Binder, Kate. IV. Title.

T385 .F699 2001
006.6'869—dc21
 00-063514

Photoshop 6 Cookbook

Dieter K. Froebisch ◊ Holger Lindner ◊ Thomas Steffen
New text and graphics by Kate Binder

Silver Pixel Press
Rochester, New York

Contents

Screening

Screen Structures

Solarizations

Colorizations

Dynamic Effects

Montages and Masks

Drawing Techniques

Illustrations

Introduction

As personal computers and off-the-shelf software become increasingly accessible and powerful, many more digital possibilities are available to the public. Personal computers, in fact, along with software programs like Adobe Photoshop®, have become the center of the creative imaging world. Because of this, lines are being blurred between traditional roles within the creative community. These changes are unsettling to some, but for those who take advantage of this new generation of imaging, they present many opportunities.

The computer, however, is only a tool, and the cognitive process of creating will never change. As with any medium, to realize the potential, the process must first be mastered—the fabled learning curve. This book is designed to help shorten that curve through its unique approach to learning Adobe Photoshop. It takes the user immediately into the working environment of digital image manipulation through the age-old method of "learning by seeing and doing."

Photoshop 6 Cookbook illustrates more than 115 image manipulation techniques, ranging from basic screening to complex montaging. These are presented as "recipes," each with the resulting image on the opposite page. The recipes are designed to get you up and running, to provide a quick reference for a variety of techniques, and to be a source of inspiration for your own creative endeavors.

Concept

The concept for this book grew out of an earlier study in traditional photographic design techniques. In place of classic, chemical-based photography, this book uses examples from the "digital photo lab." All effects are applied to the same scanned photograph, so you can easily make a visual analysis of how the manipulation affects the end result. This method also makes it easy to perceive the actual effect without getting "lost" in the image, and thus easier to judge if the raw effect is appropriate for another application.

Throughout this book, we have modified a single image into more than 115 black-and-white or color images to illustrate the infinite possibilities of computer image manipulation. The final images represent the framework of image manipulation, from rudimentary screens to complex multi-step montages. The procedures are further illustrated with screen shots of the actual dialog boxes that correspond to the instructions.

An examination of all possible forms of manipulation would be impossible to include in one volume. This book, however, focuses on exhibiting many of the building blocks essential to the creative professional. As you progress, you will not only think of *Photoshop 6 Cookbook* as instructional, but also as a source book that unveils the infinite possibilities of digital imaging.

Prerequisites

Photoshop 6 Cookbook is intended to enhance your creativity with digital image manipulation in general and with Adobe Photoshop in particular. Before beginning, you should have a working knowledge of your operating system's conventions (presumably Macintosh OS 8 or greater or Microsoft Windows 98 or greater) and Adobe Photoshop version 6 or greater.

How you set up your computer can greatly affect your system's performance. Make sure your setup meets or exceeds that of the software manufacturer's recommendations. As a general rule, the more physical RAM (Random Access Memory) you have installed, the better. Memory cheaters like RAM Doubler™ or Mac OS virtual memory are not particularly effective with Photoshop. For best results, allocate a sufficient amount of memory (three to five times the size of your largest file) to Photoshop. Designating a "scratch disk" will also help performance. Monitor setup and calibration are also vital. Consult the Adobe Photoshop manual for further details.

Technical Data

▶ *Computer hardware and software:*
Apple Macintosh G4/450 with 320 MB of RAM and a 20 GB hard drive

Mac OS 9.0

Epson Expression 636 flatbed desktop scanner

Scanning software: Epson TWAIN

Image manipulation program:
Adobe Photoshop 6.0

▶ *Original for all subjects:*
Black-and-white photographic print measuring 6.5 x 6 inches (170 x 155 mm)

▶ *Scan resolution:*
300 dots per inch (dpi) at a ratio of 1:1

▶ *Output hardware:*
All images were imported into Quark Xpress 4.1 and output at 2400 dpi through a PostScript RIP 2400 dpi to a Compugraphic 9400 imagesetter.

▶ *Printing resolution:*
150 lines per inch (lpi) with an elliptical dot

▶ *Image resolution:*
The greater the dimensions and resolution, the more memory an image file demands (both RAM and hard drive space). Set image resolution 1.5 to 2 times the final line screen at 1:1. This book was printed at 150-line screen; therefore, the halftones were set to 220 dpi. When applying effects, it's important to work in the final resolution (or greater) at all times to maintain the integrity of the image. Interpolating, or increasing the resolution, will degrade the image. When combining halftone images with line art, work in 300 dpi.

▶ *Eye image available online:*
If you would like a copy of the eye image used in this book, e-mail your request to info@silverpixelpress.com.

Platform Differences

Adobe designed Photoshop to operate on all computer platforms. Shortcuts and alternate functions, however, are performed using different keystrokes. To simplify instructions, Macintosh commands are used in the text. The chart below lists the key equivalents for the Windows platform.

Macintosh	Windows
Shift	Shift
Command	Control
Option	Alt
Control	None

Because Macintosh systems typically do not have multi-button mice, use Control-clicking to access contextual menus; on other platforms, substitute right-clicking.

Adobe Photoshop 6 Tool Palette

Marquee — Move
Lasso — Magic Wand
Crop — Slice
Airbrush — Paintbrush/Pencil
Rubber Stamp — History brush/Art History brush
Eraser — Gradient
Blur/Sharpen — Burn/Dodge/Desaturate
Path Component Selection — Text
Pen — Rectangle/Line (and other shapes)
Annotation — Eyedropper
Hand — Zoom
Foreground Color swatch — Switch colors
Default colors — Background Color swatch
Standard mode — Quick Mask mode
Standard windows — Full screen with no menu bar
Full screen with menu bar

Jump to Adobe ImageReady

Basic Techniques

The basic halftone, line art, and posterization techniques discussed in this chapter are your introduction to the virtually limitless possibilities of Adobe Photoshop. Not only are these techniques the basis for creating more complex manipulated images, they themselves are often the best solution.

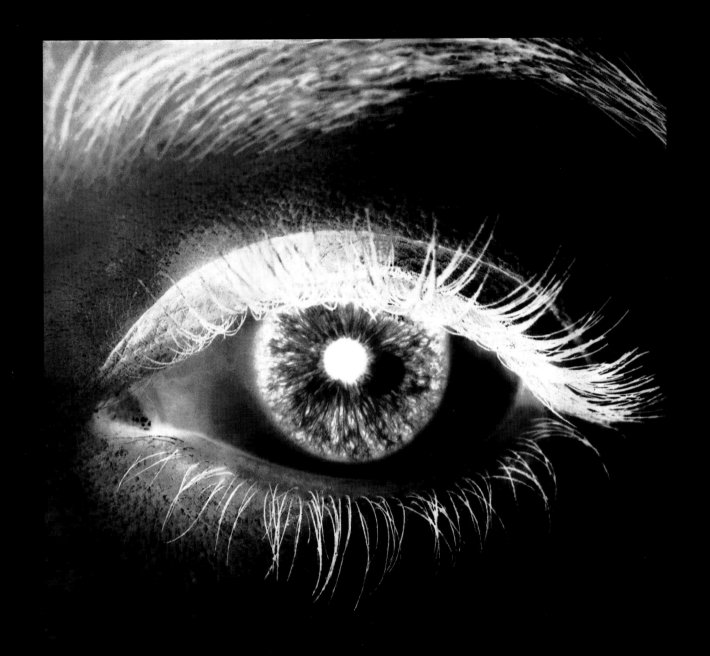

Halftone Image

This image serves as the subject or original halftone to which modifications are applied throughout this book.

▶ The image's value depth and range were adjusted using the Brightness/Contrast controls of the scanning software. The output device and monitor must be calibrated for the image on the screen to match the hardcopy output.

▶ *Page 13: **Negative Halftone***
*Open the original halftone in Photoshop (⌘O or **File**).*
*Invert the image (⌘I or **Image>Adjust**).*

▶ *Page 16: **Decreased Contrast***
Adjust the tonal range of the image.
*Open the original halftone in Photoshop (⌘O or **File**).*
*Open the Brightness/Contrast dialog box (**Image>Adjust**).*
Drag the Contrast slider to the left to decrease the contrast level.

▶ *Page 17: **Increased Contrast***
*Open the original halftone in Photoshop (⌘O or **File**).*
*Open the Brightness/Contrast dialog box (**Image>Adjust**).* ❶
 Brightness: 47 Contrast: 65
Drag the Contrast slider to the right to increase the contrast level.

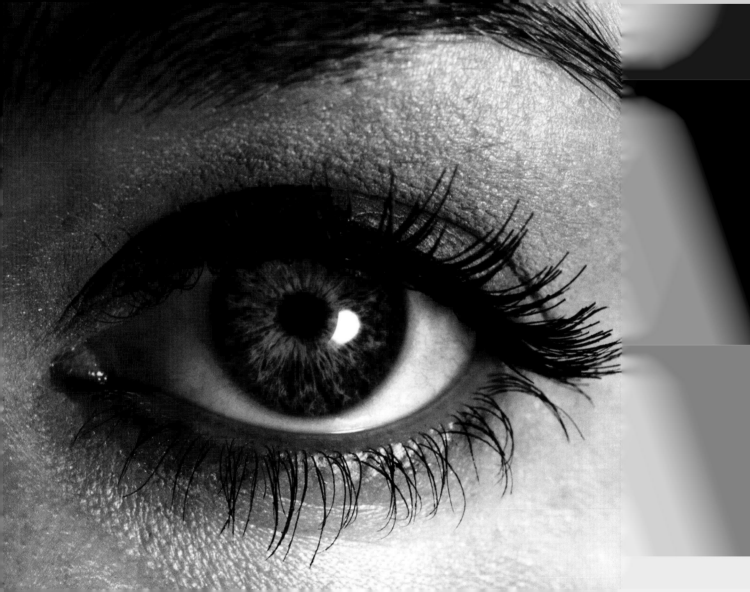

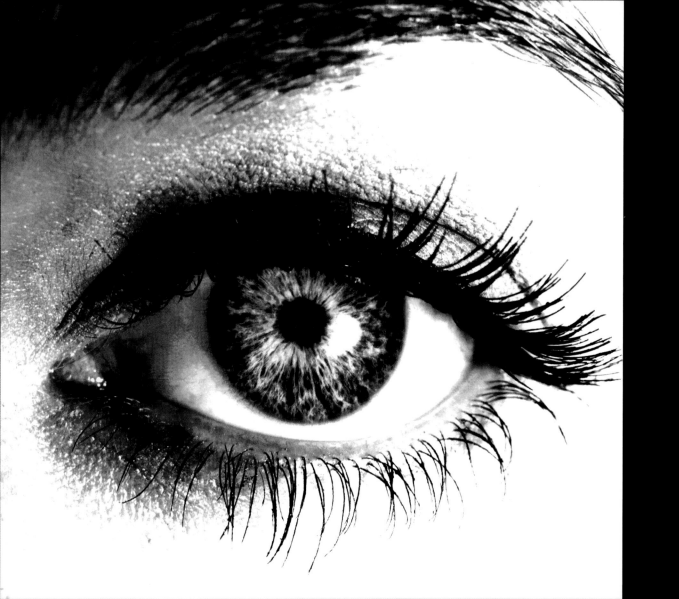

Line Art Conversion

▶ Open the original halftone in Photoshop (**⌘O** or **File**).

▶ Set the image threshold:
Open the Threshold dialog box (**Image>Adjust**).
 Threshold Level: 50

The value represents the level at which tones are converted to either black or white. Pixels with values greater than the threshold level change to white; pixels with values less than the threshold level change to black.

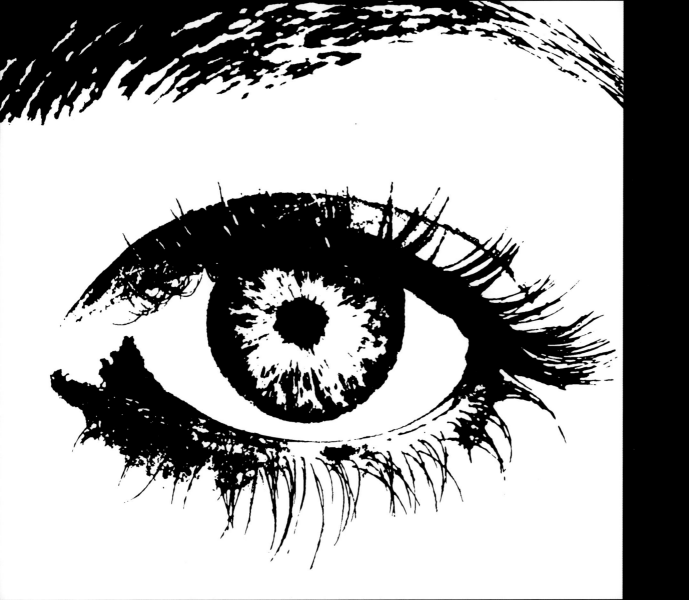

Pictogram

Convert the grayscale image to a high-contrast black-and-white image ready to be converted into a vector-based image used by drawing programs such as FreeHand or Adobe Illustrator.

▶ Open the original halftone in Photoshop (⌘O or **File**).

▶ Open the Brightness/Contrast dialog box (**Image>Adjust**). ❶
 Brightness: 50 Contrast: 100

▶ Choose Image Size (**Image**). ❷
 Select Constrain Proportions
 Select Resample Image: Bicubic
 Resolution: 600 pixels/inch
 Click OK. *The image will be increased to 600 dpi.*

▶ Apply the Gaussian Blur filter (**Filter>Blur**). ❸
 Radius: 40 pixels

▶ Open the Levels dialog box (⌘L or **Image>Adjust**). ❹
 Input Levels: Black: 130 Gamma (midtone): 1.00 White: 141

▶ Select the Bitmap mode option (**Image>Mode**).
 Output: 600 pixels/inch
 Method: 50% Threshold
 Click OK. *This will reduce the file's storage requirements while maintaining high resolution.*

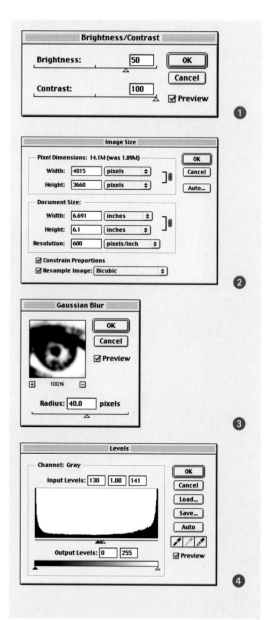

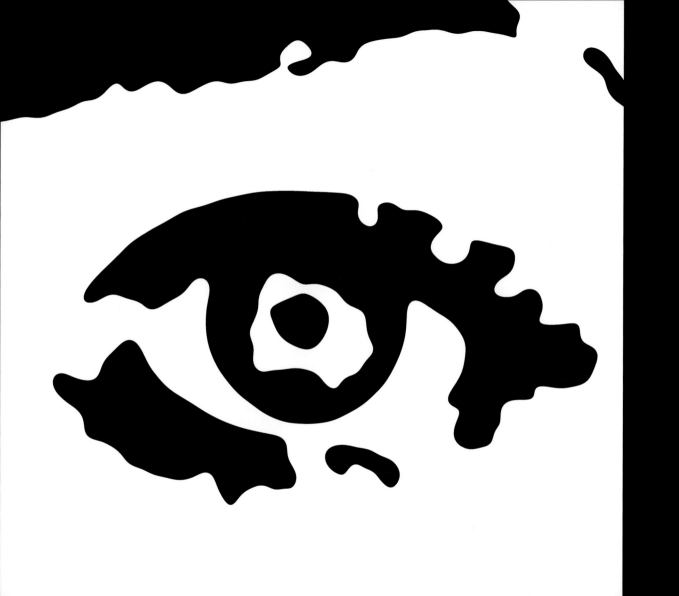

Posterization

▶ Open the original halftone in Photoshop (**⌘O** or **File**).

▶ Open the Posterize dialog box (**Image>Adjust**). ❶
 Levels: 3
 Click OK. *The image will be reduced to three tones.*

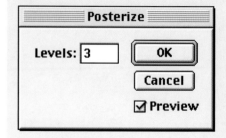

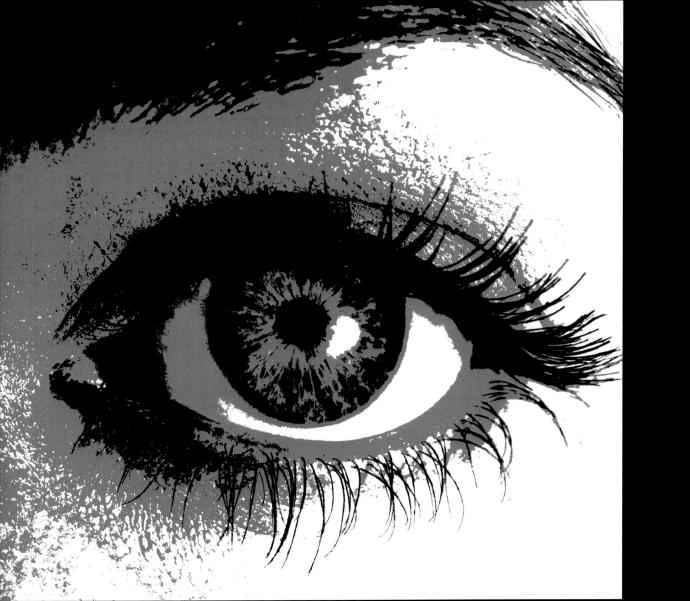

23

Color Posterization

Execute a four-level posterization, and assign custom color values.

▶ Open the original halftone in Photoshop (⌘**O** or **File**).

▶ Select the Indexed Colors mode option (**Image>Mode**).

▶ Open the Posterize dialog box (**Image>Adjust**). ❶
 Levels: 4

▶ Open the Color Table dialog box (**Image>Mode**). ❷
 Table: Custom
 Select an entire group of squares (values) from a single tonal range. This will auto-matically bring up the Color Picker. From the Color Picker, choose a first color, click OK, and then choose a last color. *Photoshop creates a gradient ranging between the first and last color chosen.*

▶ Repeat this procedure for all remaining gray levels.

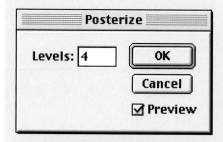

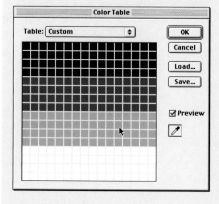

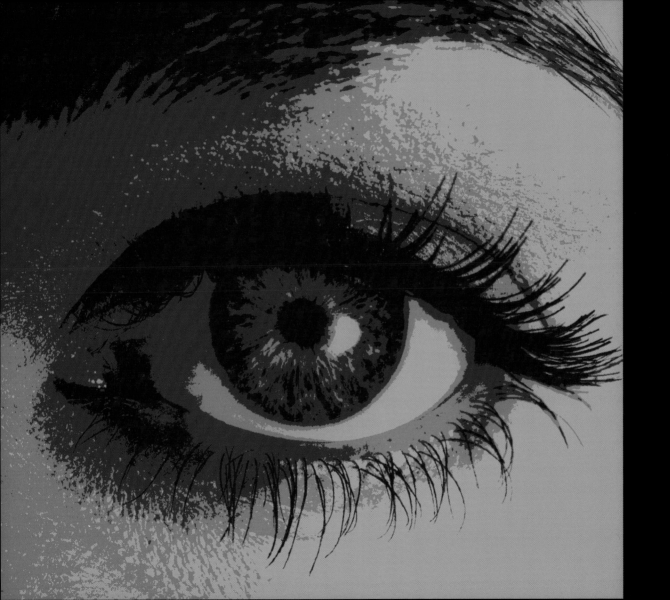

Experimental Posterization

Posterize and add color values to a black-and-white image.

▶ Open the original halftone in Photoshop (**⌘O** or **File**).

▶ Apply the Blur filter (**Filter>Blur**).

▶ Select the Indexed Colors mode option (**Image>Mode**).

▶ Open the Posterize dialog box (**Image>Adjust**). ❶
 Levels: 5

▶ Open the Color Table dialog box (**Image>Mode**). ❷
 Table: Custom
Select a group of squares (values) from a single tonal range.
From the Color Picker, choose a first color and a last color.
Click OK. *Photoshop creates a gradient ranging between the first and last color chosen.*

▶ Repeat the procedure for all remaining gray levels.

▶ Open the Posterize dialog box (**Image>Adjust**). ❸
 Levels: 8

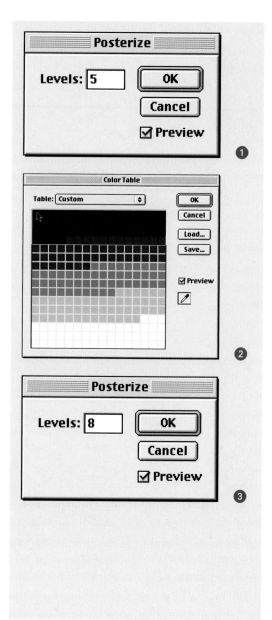

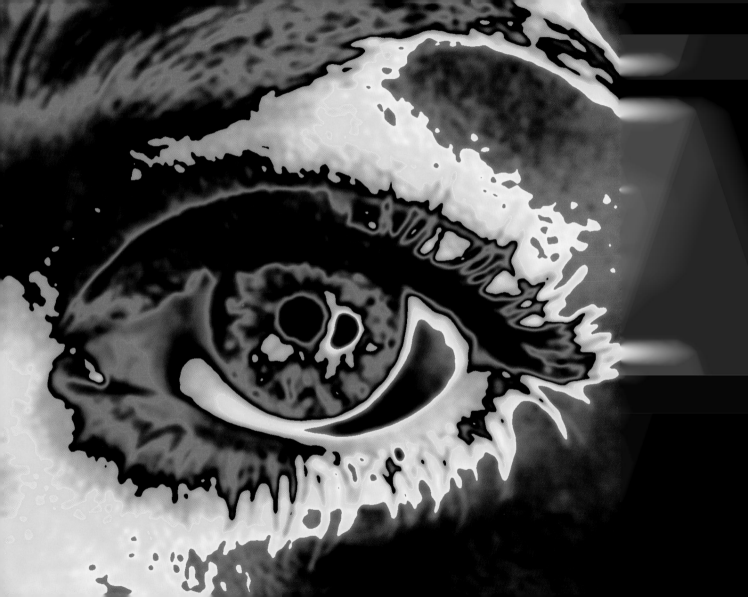

Lines and Contours

You have a choice. Reducing a grayscale image to black and white and emphasizing boundary lines is primarily a job for Photoshop. Programs such as Adobe Illustrator, Adobe Streamline, and FreeHand can be used to convert the pixel-based Photoshop image into vector-based line art, if that's what is desired. How it is done, of course, is not as important as what is done with it. The effects generated by either process can produce visually intriguing images.

Fine Line Contour Map

▶ Open the original halftone in Photoshop (⌘O or **File**).

▶ Apply the Sharpen filter (**Filter>Sharpen**).
Repeat.

Shortcut: ⌘F repeats the last applied filter.

▶ Open the Levels dialog box (⌘L or **Image>Adjust**).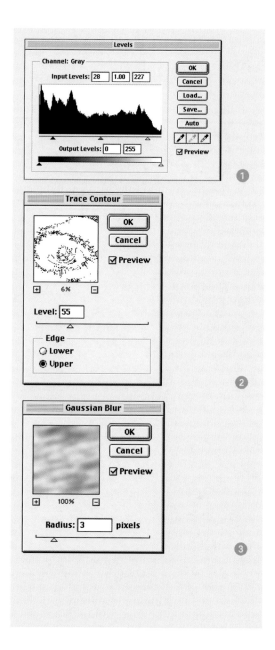
Input Levels: Black: 28 Gamma (midtone): 1.00 White: 227

▶ Apply Trace Contour filter (**Filter>Stylize**).
Level: 55 *This refers to the tonal value threshold.*
Edge: Upper *This refers to which side of the threshold to outline.*

▶ *Page 29:* **Negative Contours**
*Open the original halftone in Photoshop (⌘O or **File**).*
Set the image threshold:
*Open the Threshold dialog box (**Image>Adjust**).*
Threshold Level: Position slider to desired value (see page 18 for screen view).
*Apply the Find Edges filter (**Filter>Stylize**).*
*Apply the Gaussian Blur filter (**Filter>Blur**).*
Radius: 3 pixels
*Invert the image (⌘I or **Image>Adjust**).*

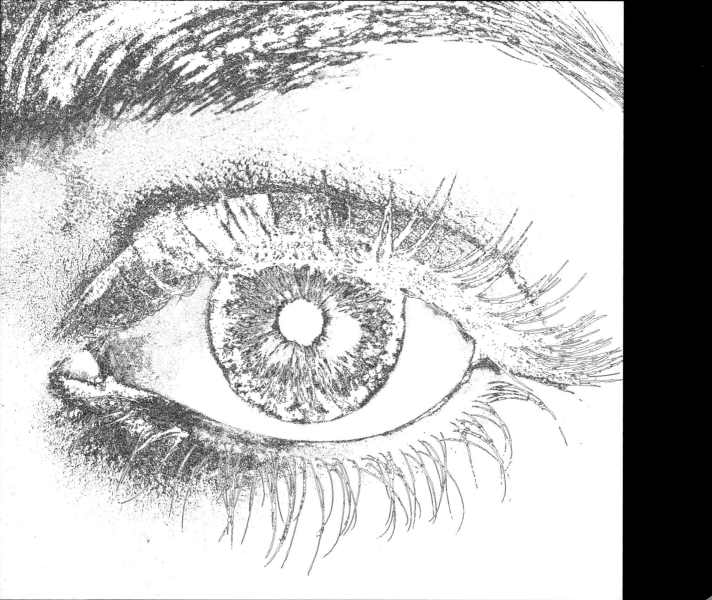

Colored Contours

▶ Open the original halftone in Photoshop (⌘O or **File**).

▶ Select the RGB mode option (**Image>Mode**).

▶ Colorize the image:
 Open the Hue/Saturation dialog box (⌘U or **Image>Adjust**). ❶
 Select Colorize and use the sliders to adjust the image.
 Hue: 40 Saturation: 100 Lightness: 0

▶ Apply the Trace Contour filter (**Filter>Stylize**). ❷
 Level: 55 Edge: Upper

▶ Invert the image (⌘I or **Image>Adjust**).

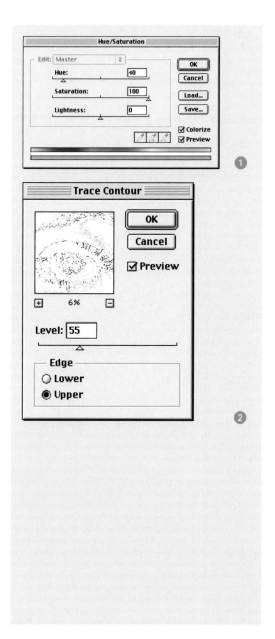

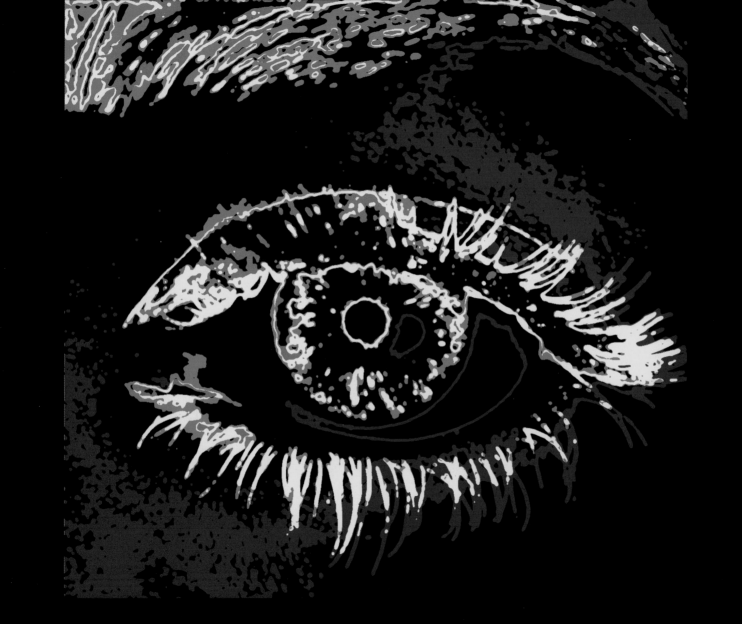

Tracing

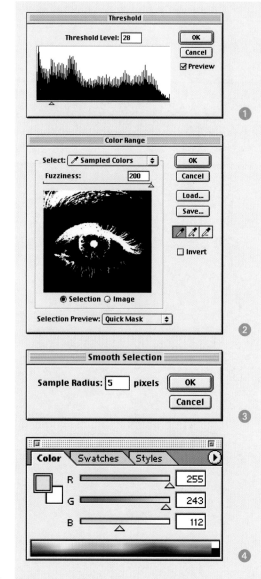

▶ Open the original halftone in Photoshop (⌘O or **File**).

▶ Set the image threshold:
Open the Threshold dialog box (**Image>Adjust**). ❶
Threshold Level: 28

▶ Select the black areas of the image using the Color Range dialog box (**Select**). ❷
Fuzziness: 200

▶ Simplify the selection by smoothing it, using the Smooth Selection dialog box
(**Select>Modify**). ❸
Sample Radius: 5

▶ Show the Paths palette (**Window**).
Create a new work path from the selection (**Paths palette menu**).

▶ Select the entire image and fill with white (**Edit**).

▶ Select the path in the Paths palette and stroke it (**Paths palette menu**).

▶ *Page 36: **Filled Contours***
Continue with the image from the preceding example. Select the RGB mode option
(**Image>Mode**). *Select the entire image and fill with a color* (**Edit**). *In the Paths palette, click*
on the work path and then use the Path Component Selection tool to select paths outlining desired
areas of image. Define a color for the areas: Mix a color in the Color palette. ❹ *Fill selected sub-*
paths with new color (**Paths palette menu**).

▶ *Page 37: **Line Art–Halftone Combination***
Continue with the image from the first example on this page. Select the RGB mode option
(**Image>Mode**). *Select the entire image and fill with white* (**Edit**). *Open a copy of the original*
image (**File**). *Using the Move tool, drag the original image into the current file* (**Shift>Drag**).
Define a color for the outline: Mix a color in the Color palette. ❹ *In the Paths palette, click on the*
Work Path and stroke it with the foreground color (**Paths palette menu**).

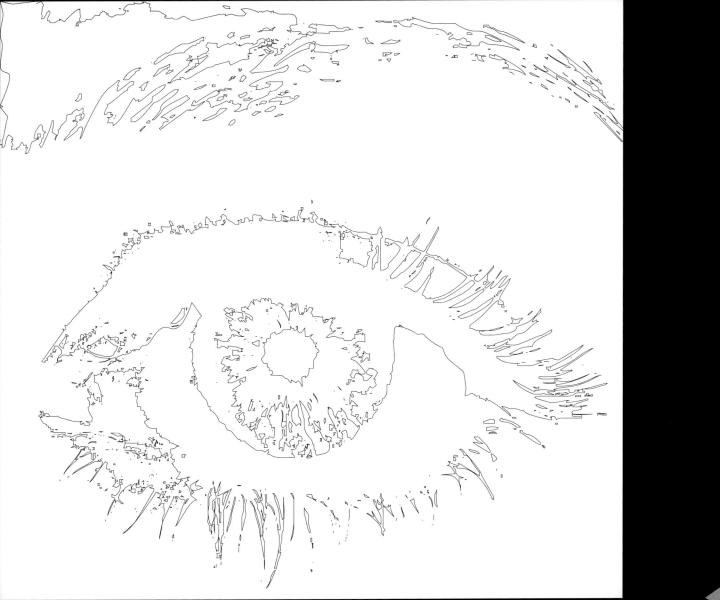

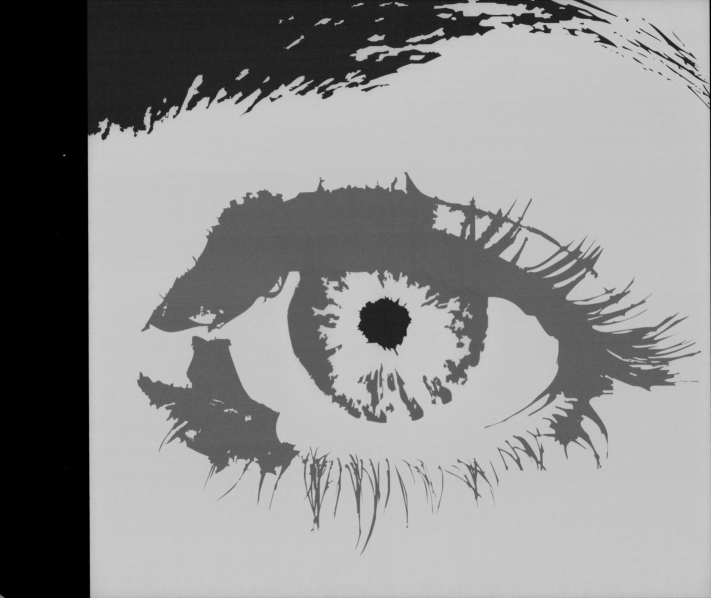

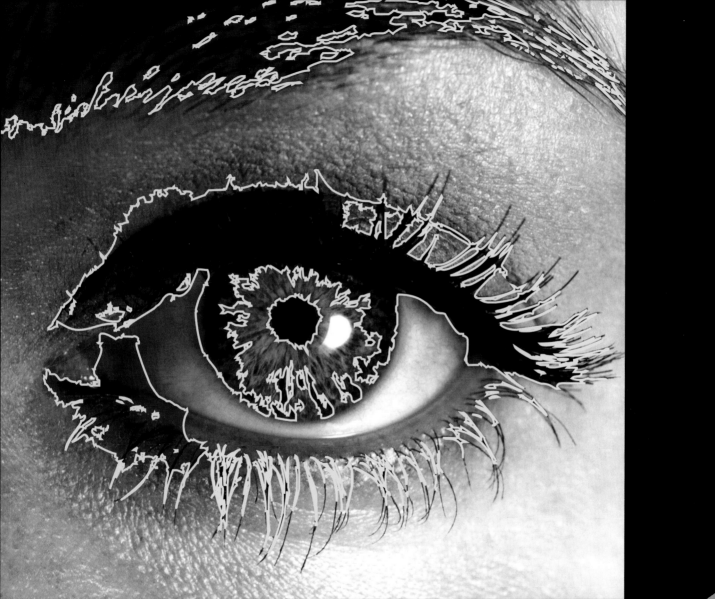

Soft Contour Lines

▶ Open the original halftone in Photoshop (⌘O or **File**).

▶ Apply the Gaussian Blur filter (**Filter>Blur**). ❶
 Radius: 8 pixels

▶ Apply the Find Edges filter (**Filter>Stylize**).
 This will identify major value transitions and delineate them with an outline.

▶ Invert the image (⌘I or **Image>Adjust**).

▶ Open the Levels dialog box (⌘L or **Image>Adjust**). ❷
 Input Levels: Black: 4 Gamma (midtone): 0.70 White: 33

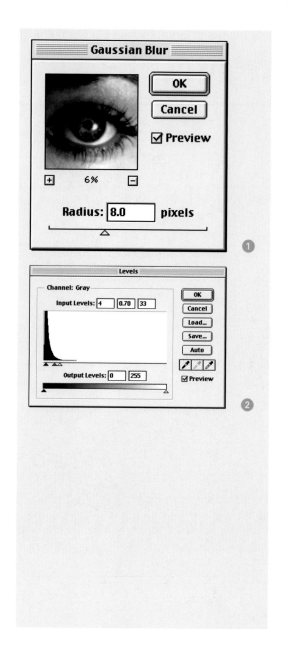

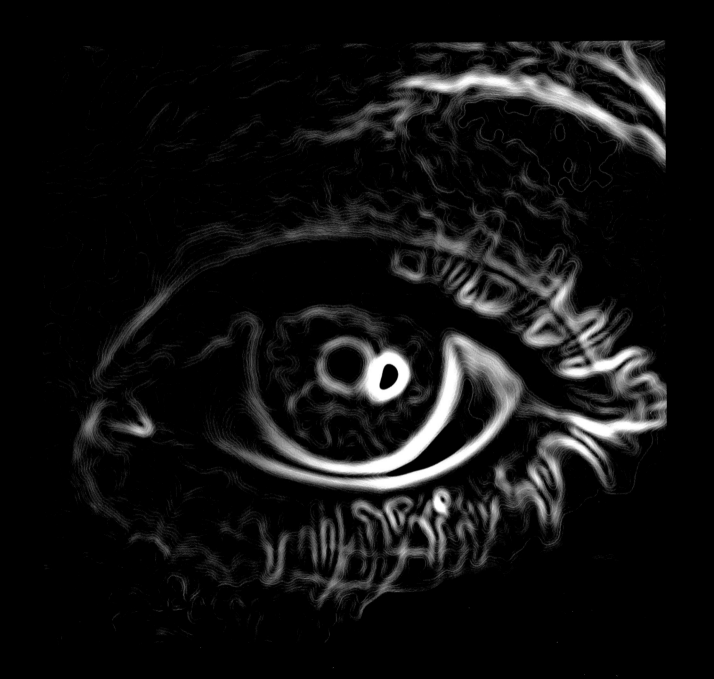

Embossing

An embossed effect is created by offsetting negative and positive versions of a transparent halftone image—and Photoshop filters do most of the work for you. Typically, this effect is used to give an image a three-dimensional appearance or to mimic an embossed surface. When embossing is coupled with additional levels of modification, line art conversions, and curve modifications, however, a wide range of complex and striking embossed effects can be created.

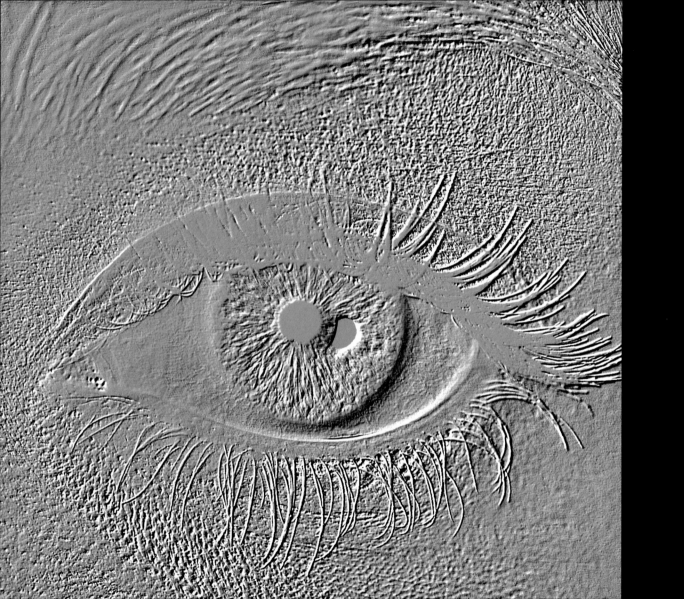

41

Embossing with Levels

▶ Open the original halftone in Photoshop (⌘O or **File**).

▶ Apply the Emboss filter (**Filter>Stylize**).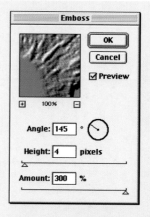
 Angle: 145° Height: 4 pixels Amount: 300%

▶ Open the Levels dialog box (⌘L or **Image>Adjust**). ❷
 Input Levels: Black: 104 Gamma (midtone): 1.00 White: 132

▶ Open the Posterize dialog box (**Image>Adjust**). ❸
 Levels: 2

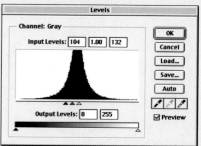

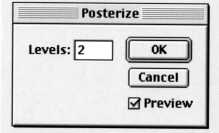

▶ *Page 41:* **Halftone Emboss**
 Open the original halftone in Photoshop (⌘O or **File***).*
 *Apply the Emboss filter (***Filter>Stylize***).* ❶
 Angle: 145° Height: 4 pixels Amount: 300%

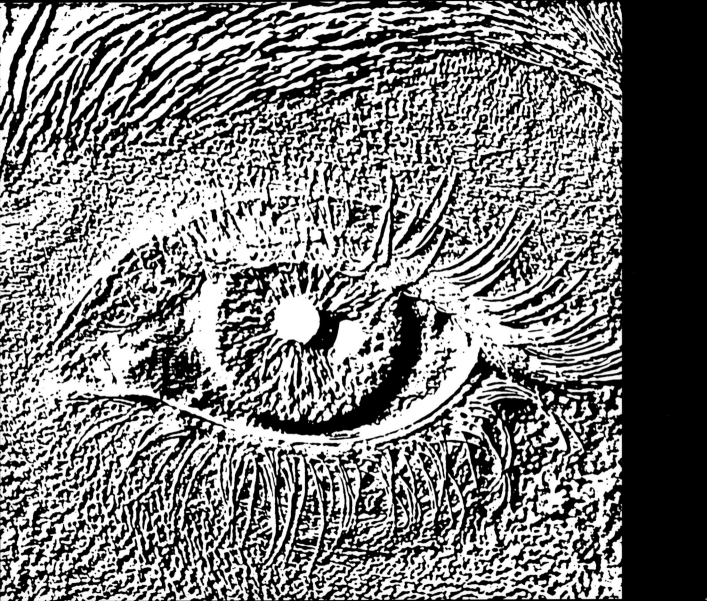

Line Embossing

▶ Open the original halftone in Photoshop (**⌘O** or **File**).

▶ Set the image threshold:
Open the Threshold dialog box (**Image>Adjust**).
 Threshold Level: 45

▶ Show the Layers palette (**Window**).
Turn the Background layer into a transparent layer by double-clicking on the Background layer in the Layers palette.

▶ Select the white areas of the image using the Color Range dialog box (**Select**).
 Fuzziness: 200

▶ Press **Delete** to clear the white areas.
Drop the selection (**⌘D** or **Select**).

▶ Duplicate the layer (**Layers palette menu**).

▶ Invert the duplicate layer (**⌘I** or **Image>Adjust**).

▶ With the Move tool (**V**), nudge the duplicate layer up and to the left.

▶ Flatten the image (**Layer**).

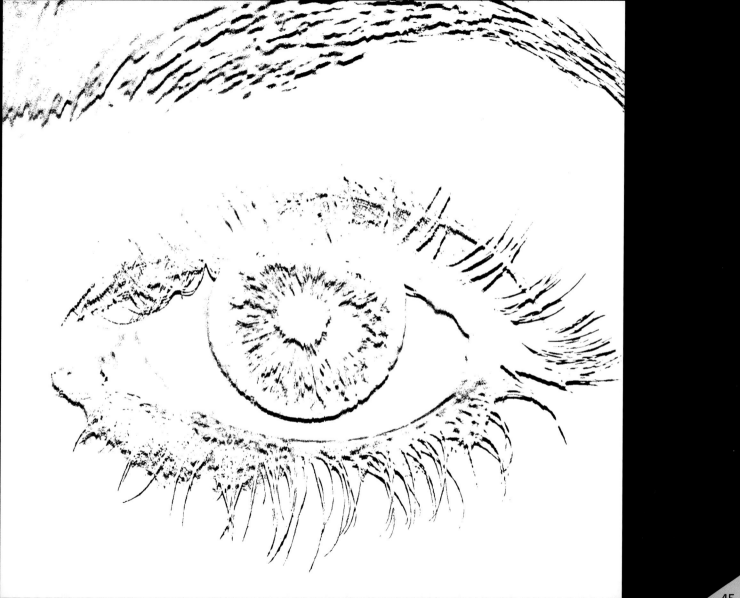

Metal Stamp

▶ Open the original halftone in Photoshop (⌘O or **File**).

▶ Apply the Gaussian Blur filter (**Filter>Blur**). ❶
 Radius: 10 pixels

▶ Apply the Find Edges filter (**Filter>Stylize**).

▶ Open the Levels dialog box (⌘L or **Image>Adjust**). ❷
 Input Levels: Black: 190 Gamma (midtone): 1.00 White: 255

▶ Invert the image (⌘I or **Image>Adjust**).

▶ Open the Brightness/Contrast dialog box (**Image>Adjust**).
 Brightness: 0 Contrast: 100

▶ Apply the Emboss filter (**Filter>Stylize**). ❸
 Angle: –40° Height: 10 pixels Amount: 100%

▶ Select the CMYK mode option (**Mode**).
 Open the Hue/Saturation dialog box (⌘U or **Image>Adjust**). ❹
 Select Colorize and use the sliders to adjust the image.

▶ Open the Channels palette (**Window**).
 Create a new channel; name it "Mask."

▶ Select the Lasso tool. Hold the Option key and select a diagonal area across the image. Use the Gradient tool to fill the selected area. Repeat over the entire image.

▶ Select None (⌘D or **Select**).

▶ Target the CMYK channel on the Channels palette.
 Load the selection (**Select**).
 Invert the selection (**Select**).

▶ Open the Levels dialog box (⌘L or **Image>Adjust**).
 Input Levels: Black: 0 Gamma (midtone): 0.70 White: 255

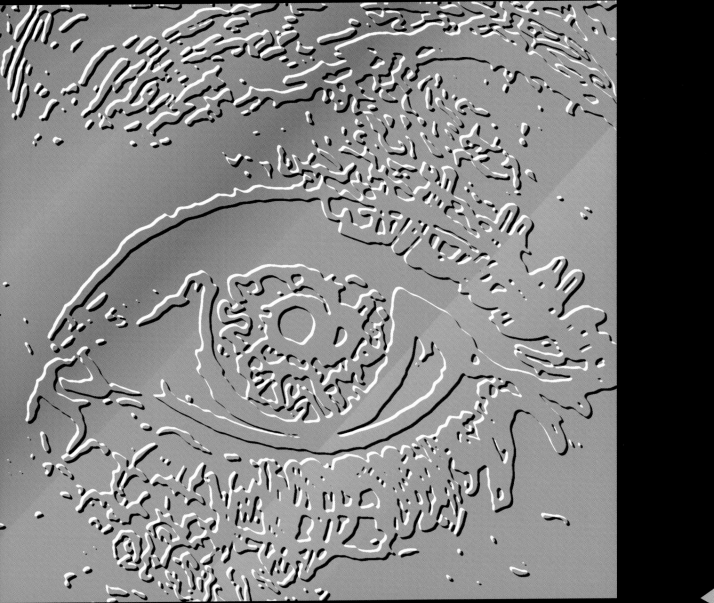

Metal Embossing

▶ Open the original halftone in Photoshop (**⌘O** or **File**).

▶ Apply the Gaussian Blur filter (**Filter>Blur**).
 Radius: 10 pixels

▶ Apply the Find Edges filter (**Filter>Stylize**).

▶ Open the Levels dialog box (**⌘L** or **Image>Adjust**).
 Input Levels: Black: 225 Gamma (midtone): 0.81 White: 255

▶ Open the Curves dialog box (**⌘M** or **Image>Adjust**).
 Click on the curve, add points, and adjust the dynamic of the curve.

▶ Select the CMYK mode option (**Mode**).

▶ Open the Hue/Saturation dialog box (**⌘U** or **Image>Adjust**).
 Select Colorize, and use the sliders to adjust the image.
 Hue: –175 Saturation: 100 Lightness: 3

▶ Open the Levels dialog box (**⌘L** or **Image>Adjust**).
 Increase black Input Levels and decrease white Input Levels by moving sliders
 toward the middle.

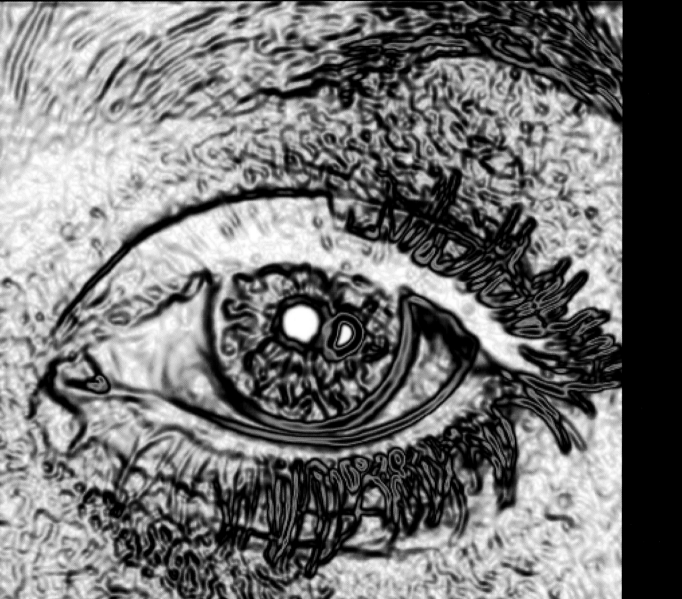

Marble Embossing

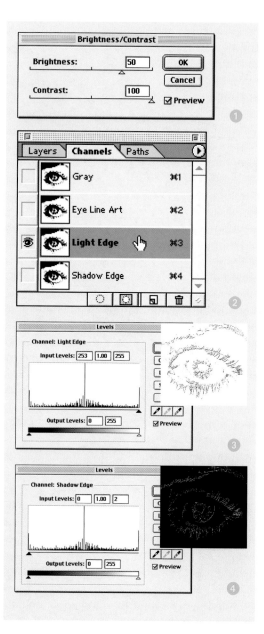

▶ Create a grayscale scan of a marble texture. Make the file the same size and resolution as the original halftone. Open the scan in Photoshop (**⌘O** or **File**).

▶ Open the original halftone in Photoshop (**⌘O** or **File**).
Open the Brightness/Contrast dialog box (**Image>Adjust**). ❶
 Brightness: 50 Contrast: 100

▶ Select All (**⌘A** or **Select**), and copy (**⌘C** or **Edit**) the image.
Show the Channels palette (**Window**).
Create three new channels; name them "Eye Line Art," "Light Edge," and "Shadow Edge." Paste the copied image into each channel (**⌘V** or **Edit**).

▶ Target the Light Edge channel. ❷
Apply the Emboss filter (**Filter>Stylize**).
 Angle: –45° Height: 7 pixels Amount: 100%
Open the Levels dialog box (**⌘L** or **Image>Adjust**). ❸
 Input Levels: Black: 253 Gamma (midtone): 1.00 White: 255

▶ Target the Shadow Edge channel. Repeat the Emboss filter.
Shortcut: ⌘F repeats the last-performed filter.
Open the Levels dialog box (**⌘L** or **Image>Adjust**). ❹
 Input Levels: Black: 0 Gamma (midtone): 1.00 White: 2

▶ Target the marble image. Select All (**⌘A** or **Select**), and copy (**⌘C** or **Edit**) the image.
Target the original image. Target the Gray channel.
Paste the copied image into the channel (**⌘V** or **Edit**).

▶ Load Selection (**Select**).
 Channel: Eye Line Art
Shortcut: Hold the ⌘ key and click on the channel.
Invert the selection (**Select**).
Open the Levels dialog box (**⌘L** or **Image>Adjust**).
 Input Levels: Black: 80 Gamma (midtone): 1.00 White: 255

▶ Load Selection (**Select**).
 Channel: Light Edge
Open the Levels dialog box (**⌘L** or **Image>Adjust**).
 Input Levels: Black: 0 Gamma (midtone): 1.00 White: 80

▶ Load Selection (**Select**).
 Channel: Shadow Edge
Invert the selection (**Select**).
Open the Levels dialog box (**⌘L** or **Image>Adjust**).
 Input Levels: Black: 100 Gamma (midtone): 0.16 White: 255

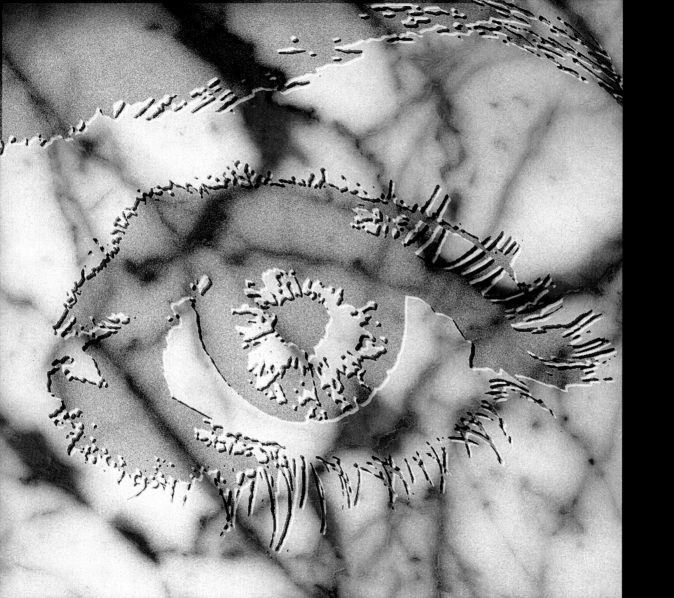

Embossed Star

▶ Open the original halftone in Photoshop (**⌘O** or **File**).

▶ Select the CMYK mode option (**Image>Mode**).

▶ Duplicate the Background layer (**Layer**); name it "Background 1."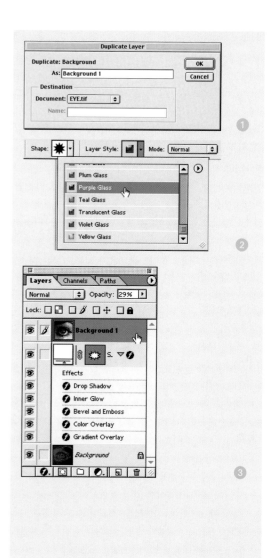

▶ Click on the Foreground Color swatch on the Tool palette.
Define the color as:
C: 88% M: 77% Y: 0% K: 0%

▶ Select the Custom Shape tool.
Shape: 10-point star
Layer Style: Button: Purple Glass
Mode: Normal

▶ Place cursor in the center of the eye and draw star as shown. Hold the option key to draw out from the center.

▶ Make the layer color white (**Layer>Layer Content>Solid Color**).
Shortcut: Double-click on the Layer thumbnail in the Layers palette.

▶ Make these modifications to the Layer Style options:
Inner Glow:
Color: Solid C: 3% M: 0% Y: 31% K: 0%
Color Overlay:
C: 61% M: 0% Y: 29% K: 0%
Opacity: 64%

▶ Move Background 1 to top of layers palette.
Layer opacity: 29%.

▶ Select the Background layer.

▶ Apply the Solarize filter (**Filter>Stylize**).

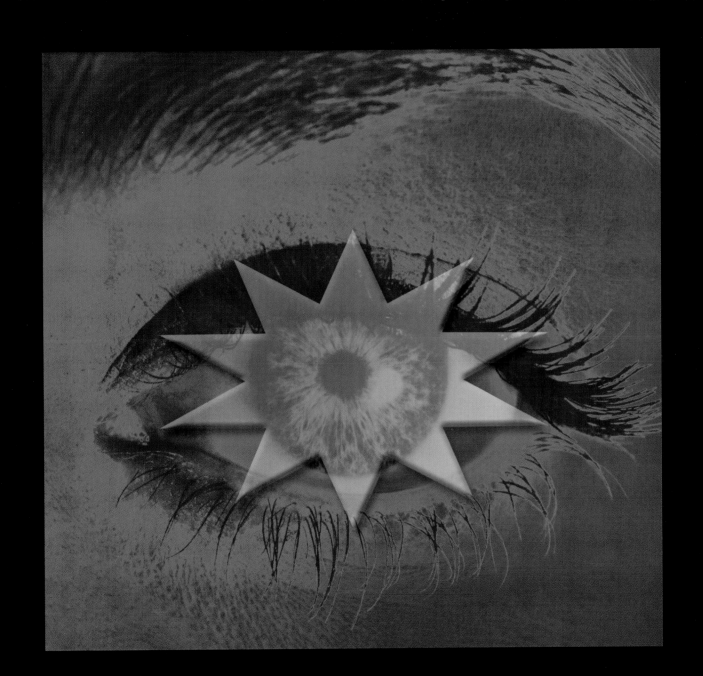

Screening

When an image is screened, all gray levels are converted into lines, dots, or squares of varying densities and sizes. This kind of screening is used to prepare halftone images for printing. Using extreme enlargements and combining the various screen shapes can create a wide variety of graphic effects.

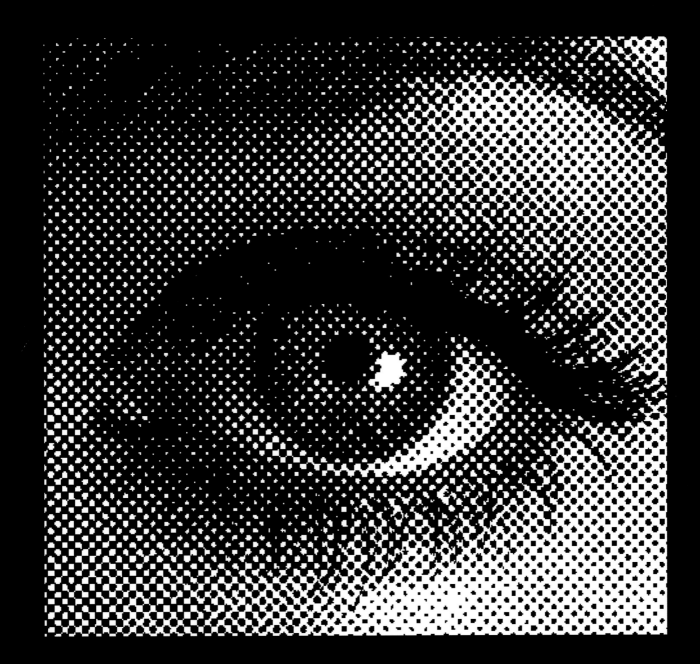

Basic Screen

▶ Open the original halftone in Photoshop (⌘O or **File**).
▶ Select the Bitmap mode option (**Image>Mode**).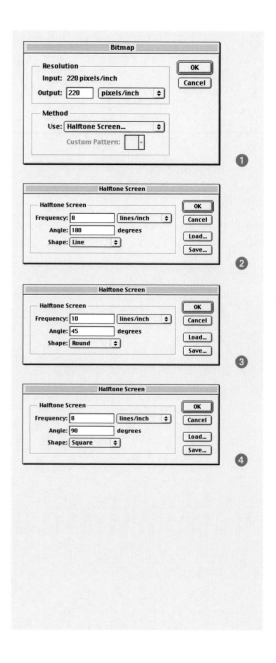
 Output: 220 pixels/inch
 Method: Halftone Screen
 Click OK. *This opens the Halftone Screen dialog box.* ❷
 Frequency: 8 Angle: 180° Shape: Line

▶ *Page 55:* **Coarse Dot Screen**
 Open the original halftone in Photoshop (⌘O or **File**).
 *Select the Bitmap mode option (***Image>Mode***).* ❶
 Output: 220 pixels/inch
 Method: Halftone Screen
 Click OK. This opens the Halftone Screen dialog box. ❸
 Frequency: 10 Angle: 45° Shape: Round

▶ *Page 58:* **Square Screen**
 Open the original halftone in Photoshop (⌘O or **File**).
 *Select the Bitmap mode option (***Image>Mode***).* ❶
 Method: Halftone Screen
 Output: 220 pixels/inch
 Click OK. This opens the Halftone Screen dialog box. ❹
 Frequency: 8 Angle: 90° Shape: Square

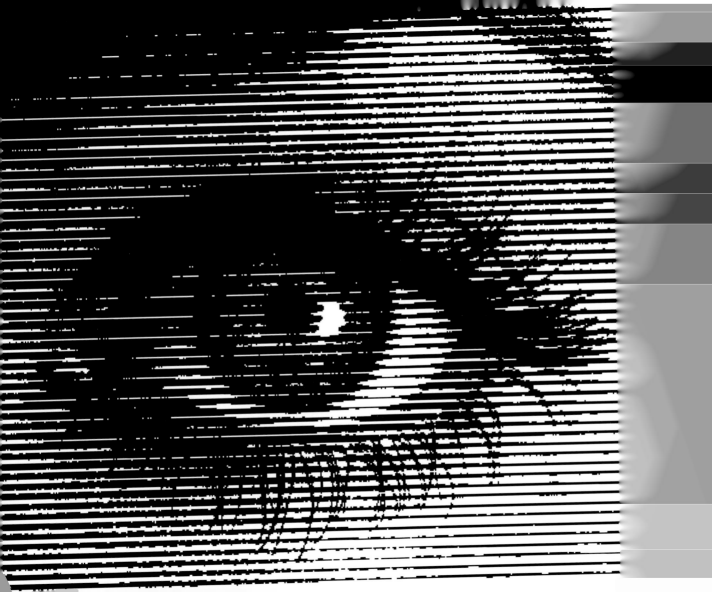

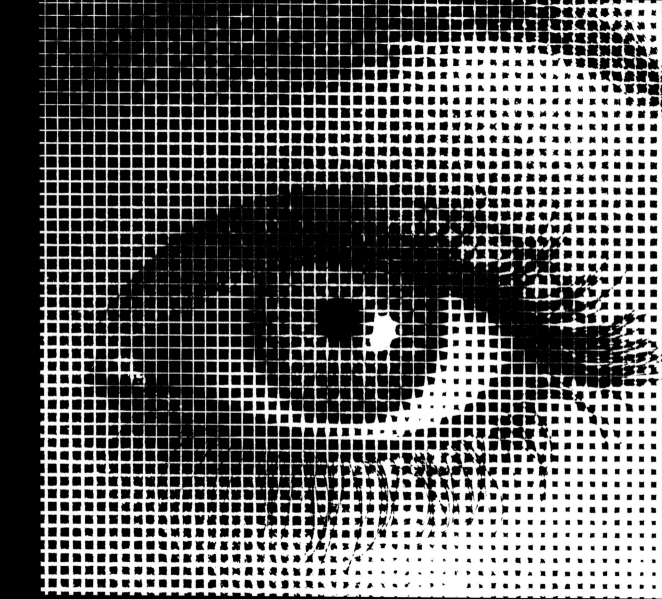

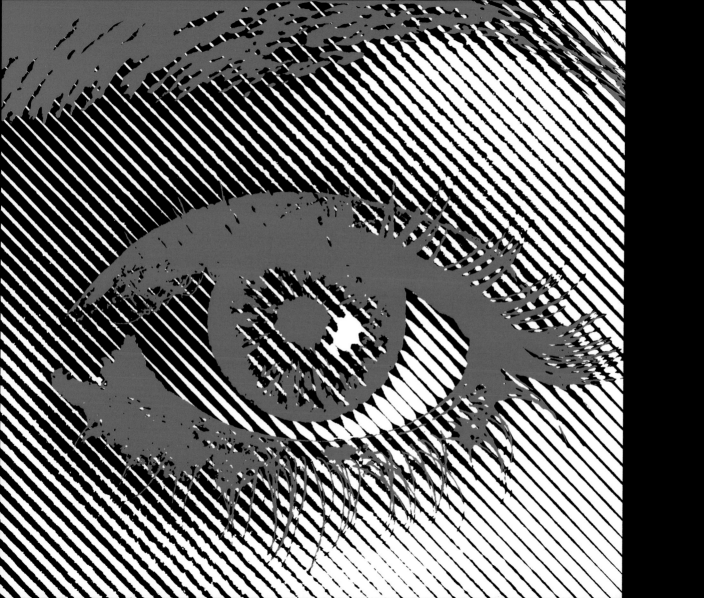

Matrix Screen

▶ Open the original halftone in Photoshop (**⌘O** or **File**).

▶ Select the Bitmap mode option (**Image>Mode**).
 Output: 40 pixels/inch
 Method: Pattern Dither
This produces a bitmapped image that converts the grayscale tonal values into geometric arrange-ments of black-and-white dots.

▶ *Page 59: **Line Screen–Line Art Combination***
*Open the original halftone in Photoshop (**⌘O** or **File**).*
*Select All (**⌘A** or **Select**), and copy (**⌘C** or **Edit**) the image.*
*Select the Bitmap mode option (**Image>Mode**).*
 Output: 220 pixels/inch Method: Halftone Screen
Click OK. This opens the Halftone dialog box.
 Frequency: 8 Angle: 45° Shape: Line
*Select the Grayscale mode option (**Image>Mode**).*
*Show the Channels palette (**Window**).*
Create a new channel.
*Paste the copied image into the new channel (**⌘V** or **Edit**).*
*Open the Brightness/Contrast dialog box (**Image>Adjust**).*
 Brightness: 50 Contrast: 100
*Invert the image (**⌘I** or **Image>Adjust**).*
Target the Gray channel.
*Show the Layers palette (**Window**). Target the background layer.*
*Load Selection to the layer (**Select**).*
*Select the CMYK mode option (**Image>Mode**).*
Click on the Foreground Color swatch and choose a color.
*Apply a Fill (**Edit**).*
*Shortcut: **Shift Delete** brings up the Fill dialog box.*
 Use: Foreground Color Opacity: 100%
 Paint Mode: Normal

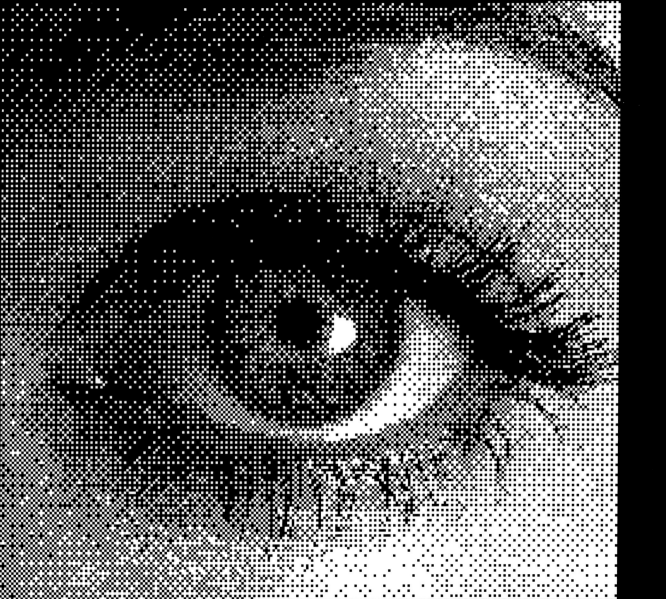

Grain Screen

▶ Open the original halftone in Photoshop (⌘O or **File**).

▶ Apply the High Pass filter (**Filter>Other**). ❶
 Radius: 10 pixels

▶ Open the Levels dialog box (⌘L or **Image>Adjust**). ❷
 Input Levels: Black: 118 Gamma (midtone): 0.97 White: 179

▶ Select the Bitmap mode option (**Image>Mode**).
 Output: 50 pixels/inch Method: Diffusion Dither

▶ Select the Grayscale mode option (**Image>Mode**).
 Size Ratio: 1

▶ Set the Image Size (**Image**). ❸
 Deselect Resample Image Resolution: 600 pixels/inch

▶ Open the Levels dialog box (⌘L or **Image>Adjust**). ❹
 Input Levels: Black: 40 Gamma (midtone): 1.00 White: 255

▶ Select the Bitmap mode option (**Image>Mode**).
 Output: 600 pixels/inch Method: 50% Threshold

▶ *Page 64:* **Grain Screen**
 Open the original halftone in Photoshop (⌘O or **File***).*
 *Select the Bitmap mode option (***Image>Mode***).*
 Output: 100 pixels/inch Method: Diffusion Dither

▶ *Page 65:* **Grain Screen with Contour Lines**
 Open the original halftone in Photoshop (⌘O or **File***).*
 *Select the Lab Color mode option (***Image>Mode***).*
 The conversion will provide three image channels: L (lightness), a (green to red), and b (blue).
 *Apply the Find Edges filter (***Filter>Stylize***).*
 *Select the Grayscale mode option (***Image>Mode***).*
 *Select the Bitmap mode option (***Image>Mode***).*
 Output: 100 pixels/inch Method: Diffusion Dither

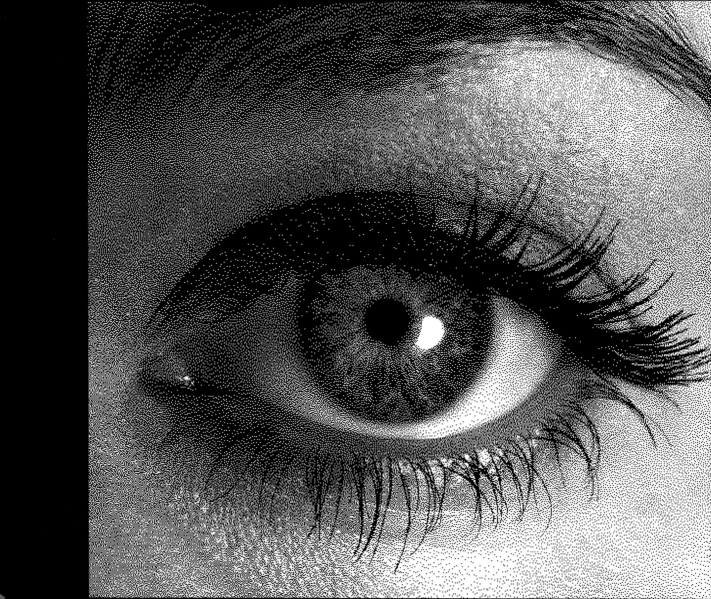

Random Screen

▶ Open the original halftone in Photoshop (⌘O or **File**).

▶ Select the Bitmap mode option (**Image>Mode**).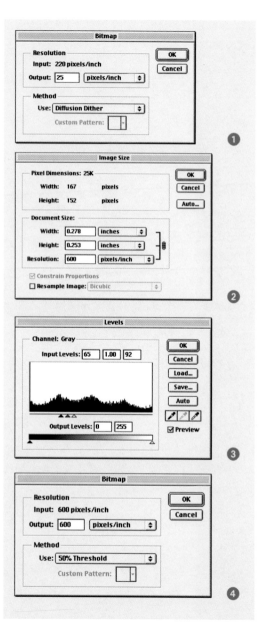
 Output: 25 pixels/inch Method: Diffusion Dither
 This converts the grayscale tonal values into a random grainy texture of black-and-white dots.

▶ Select the Grayscale mode option (**Image>Mode**).
 Size ratio: 1

▶ Change the image size (**Image**). ②
 Deselect Resample Image Resolution: 600 pixels/inch

▶ Open the Levels dialog box (⌘L or **Image>Adjust**). ③
 Input Levels: Black: 65 Gamma (midtone): 1.00 White: 92

▶ Select the Bitmap mode option (**Image>Mode**). ④
 Output: 600 pixels/inch Method: 50% Threshold

A similar effect can also be achieved with a hands-on approach: Print a reduced, randomized version of the image on an inkjet printer. Then enlarge it again on a photocopier or scanner.

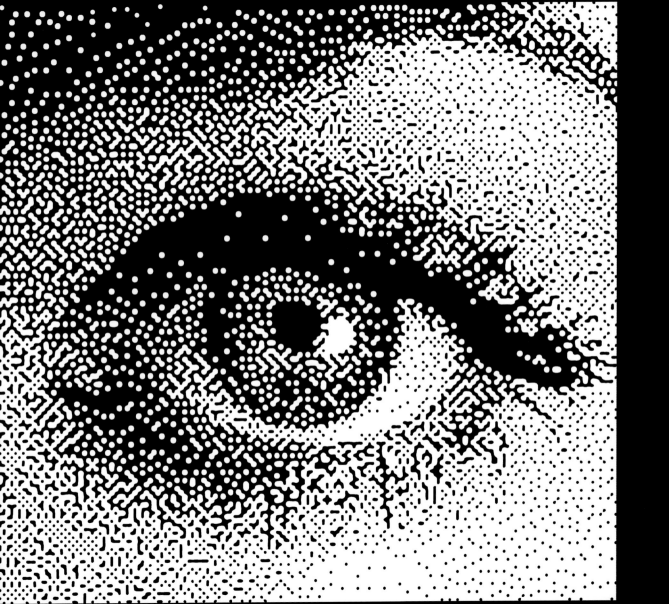

Mosaic Effects

▶ Open the original halftone in Photoshop (⌘O or **File**).

▶ Open the Levels dialog box (⌘L or **Image>Adjust**).
 Increase black Input Levels and decrease white Input Levels.
 Input Levels: Black: 27 Gamma (midtone): 1.00 White: 221

▶ Reduce the image resolution:
 Choose Image Size (**Image**). ❷
 Select Constrain Proportions
 Select Resample Image: Bicubic
 Resolution: 10 pixels/inch

▶ Apply the Sharpen More filter (**Filter>Sharpen**).

▶ Use your results for the examples on pages 70 and 71.

▶ *Page 70:* ***Two-Bit Mosaic***
 Proceed with the resulting image from "Mosaic Effects."
 *Open the Brightness/Contrast dialog box (**Image>Adjust**). ❸*
 Brightness: 0 Contrast: 100

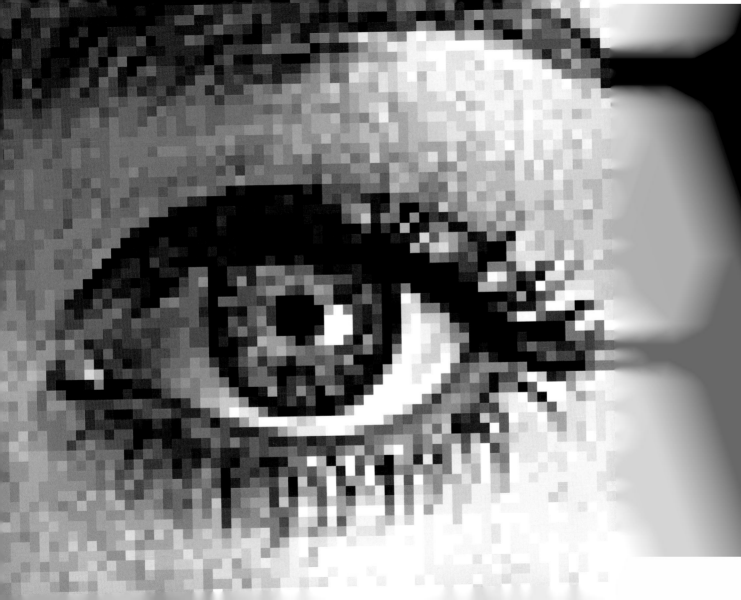

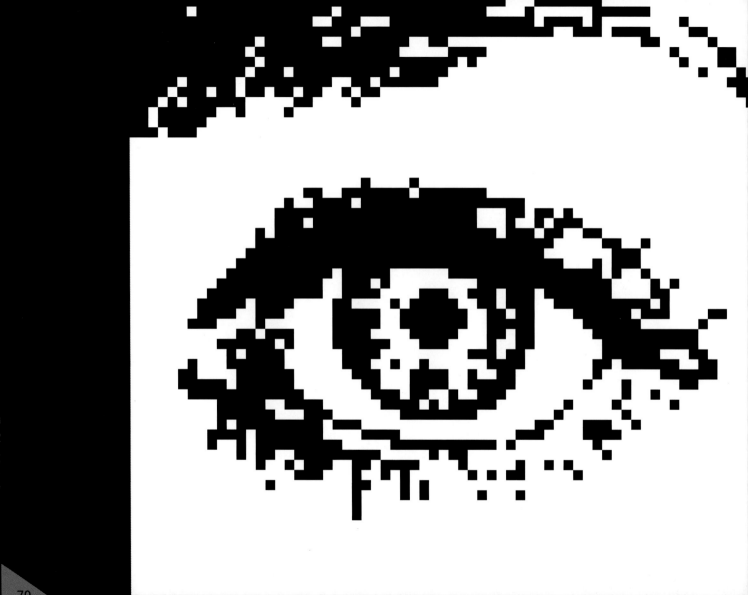

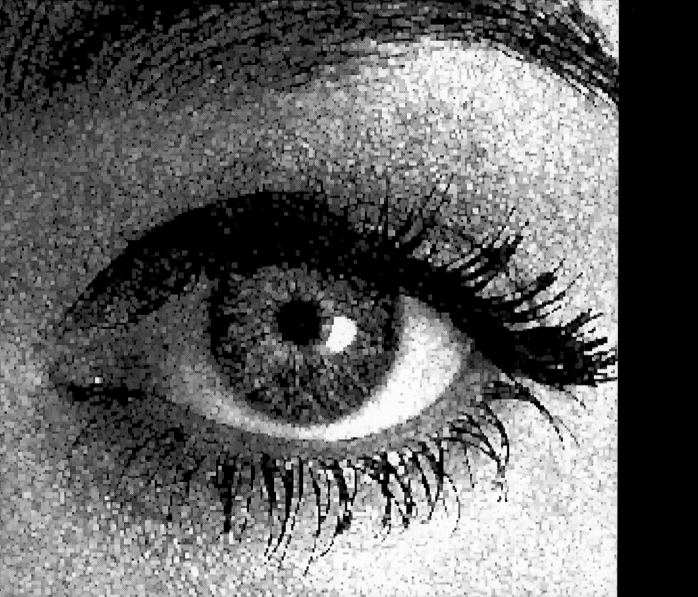

Pointillist

▶ Open the original halftone in Photoshop (**⌘O** or **File**).

▶ Select the CMYK mode option (**Image>Mode**).

▶ Apply the Pointillize filter (**Filter>Pixelate**). ❶
 Cell size: 17

▶ Apply the Crystallize filter (**Filter>Pixelate**). ❷
 Cell size: 17

▶ *Page 71:* ***Detail, Mosaic***
 Proceed with the resulting image from "Mosaic Effects" on pages 68–69.
 *Change the image resolution: Choose Image Size (****Image****).*
 Constrain: Proportions Resolution: 72 pixels/inch
 *Apply the Unsharp Mask filter (****Filter>Sharpen****).* ❸
 Amount: 50% Radius: 1 pixel Threshold: 0 levels
 Apply this filter a total of four times.
 Shortcut: Use ***⌘F*** *to reapply your last used filter.*
 Apply the following filters in this order:
 *Add Noise filter (****Filter>Noise****).* ❹
 Amount: 32 Distribution: Gaussian
 *Maximum filter (****Filter>Other****)*
 Radius: 1 pixel
 *Minimum filter (****Filter>Other****)*
 Radius: 1 pixel
 *Unsharp Mask filter (****Filter>Sharpen****)*
 Amount: 50% Radius: 1 pixel Threshold: 0 levels
 *Select the Indexed Color mode option (****Image>Mode****).*
 *Open the Hue/Saturation dialog box (****⌘U*** *or* ***Image>Adjust****).* ❺
 Select Colorize and use the sliders to adjust the image.
 Hue: 235 Saturation: 50 Lightness: 10

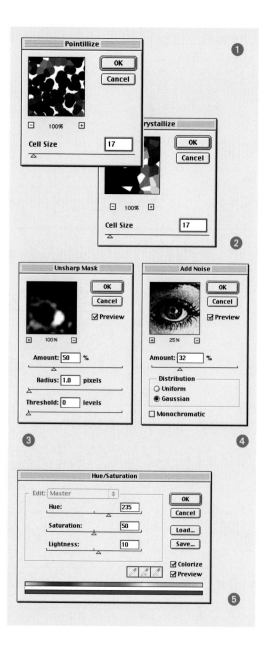

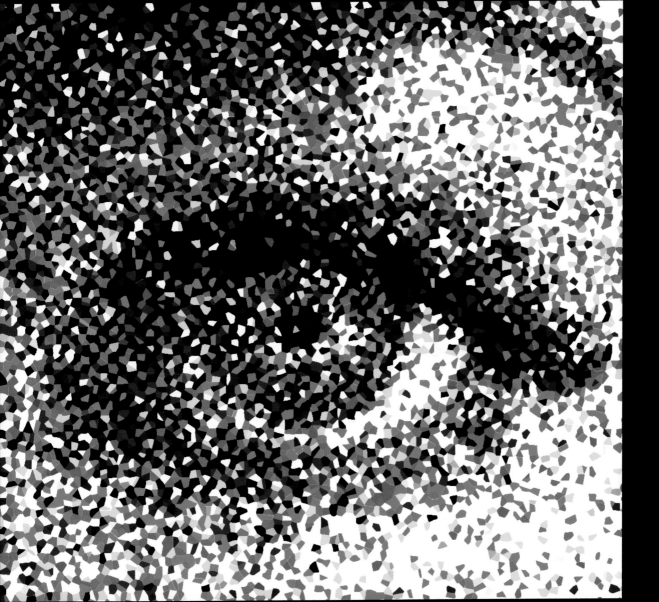

Color Halftone Gradient

▶ Open the original halftone in Photoshop (⌘O or **File**).

▶ Use the Lasso tool to select a triangular area in the upper right half of the image. *Hold the Option key and click on three appropriate points.*

▶ Apply a Feather to the selection (**Select**). ❶
 Radius: 100 pixels

▶ Select the CMYK mode option (**Image>Mode**).

▶ Apply the Color Halftone filter (**Filter>Pixelate**). ❷
 Maximum radius: 25 pixels
 Use default screen angles.

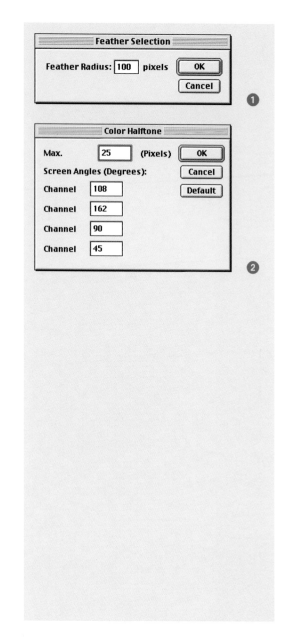

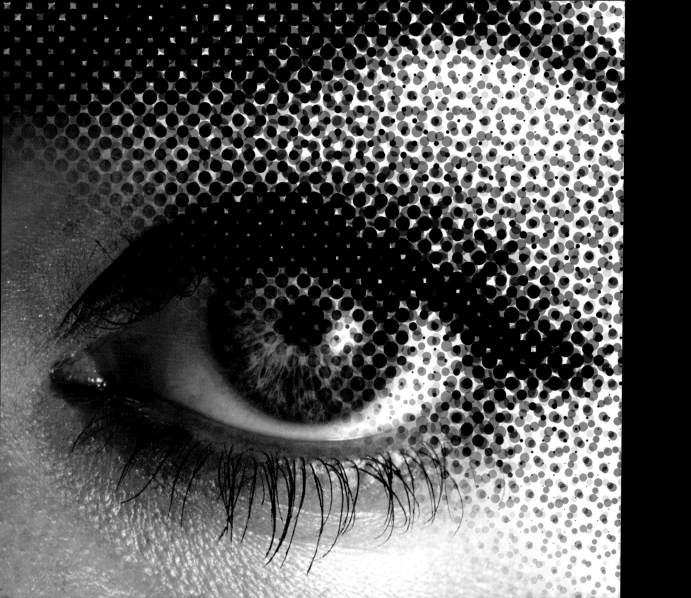

Shifted Pointillization

▶ Open the original halftone in Photoshop (⌘O or **File**).

▶ Reduce the image resolution:
 Choose Image Size (**Image**). **①**
 Select Constrain Proportions
 Select Resample Image: Bicubic
 Resolution: 12 pixels/inch

▶ Select the CMYK mode option (**Image>Mode**).

▶ Show the Channels palette (**Window**) and target the Cyan channel. **②**
 Offset the channel using the Move tool or by applying the Offset filter
 (**Filter>Other**).

▶ Target the Yellow and Magenta channels and offset each in a different direction.

▶ Target the Black channel. **③**
 Select All (⌘A or **Select**).
 Delete the selection.

▶ Target the CMYK channel.
 Select Auto Levels (**Image>Adjust**).

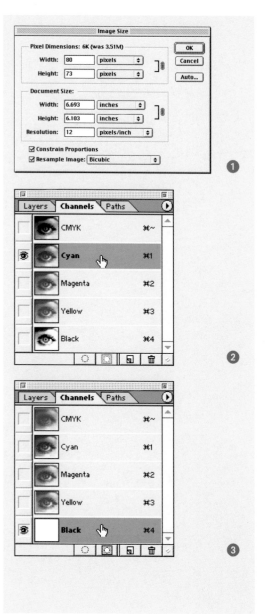

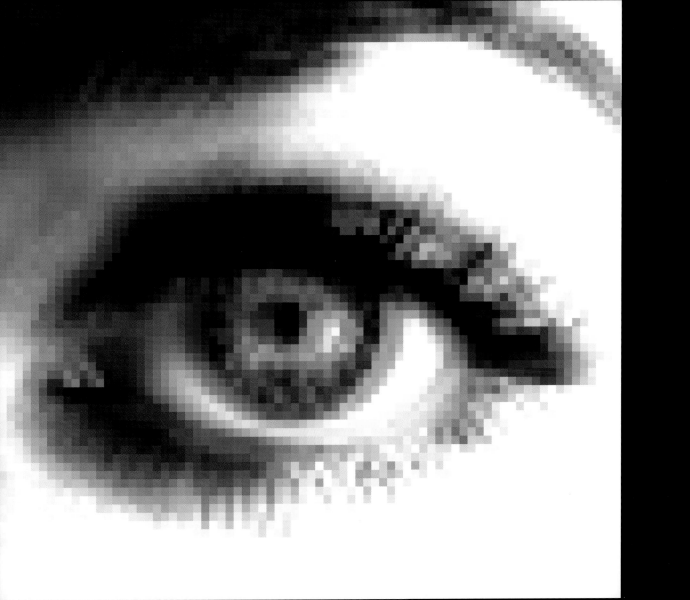

Screen Structures

Similar results to those described in the Screening chapter can be achieved without converting the gray levels into lines or dots. Combining scanned images or line art with halftones can produce interesting enhancements to images.

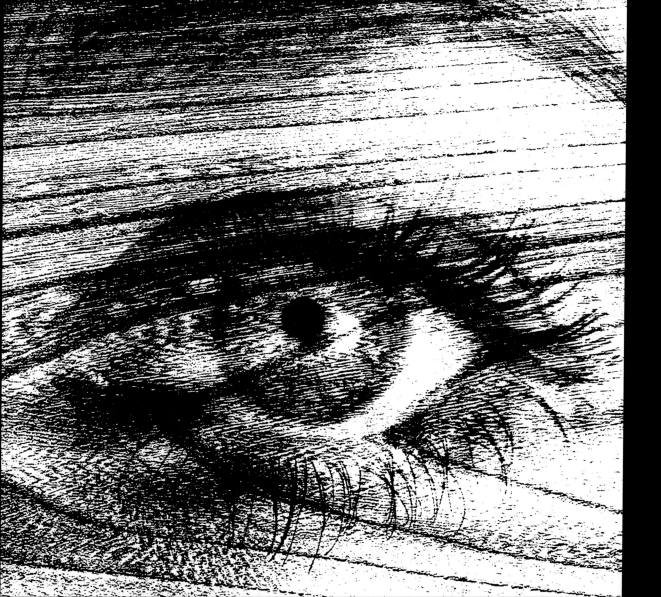

Pen and Ink

▶ Scan a pen-and-ink pattern in black and white; make sure this file is the same size and resolution as the original halftone. **❶**

▶ Open the scan in Photoshop (**⌘O** or **File**).

▶ Select the Grayscale mode option (**Image>Mode**).

▶ Apply the Blur More filter (**Filter>Blur**).

▶ Further distort the pattern by increasing the contrast.
Open the Levels dialog box (**⌘L** or **Image>Adjust**).
Increase the black Input Levels and decrease white Input Levels by sliding them toward the middle.
Click OK. *The image contrast will increase.*

▶ Define this image as a fill pattern:
Select the entire pen-and-ink pattern (**⌘A** or **Select**).
Define Pattern (**Edit**).

▶ Open the original halftone in Photoshop (**⌘O** or **File**).

▶ Select the Bitmap mode option (**Image>Mode**). **❷**
 Output: 300 pixels/inch Method: Custom Pattern

▶ *Page 79: **Wood Grain***
Scan a wood-grain texture in place of the pen-and-ink sketch pattern.
Proceed as above.

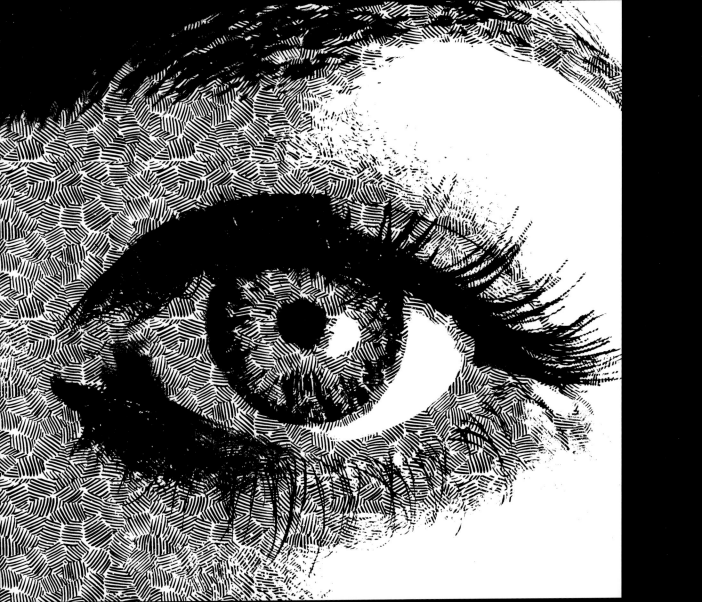

Wrinkled Texture

▶ Scan a crumpled piece of paper in grayscale; make the file the same size and resolution as the original halftone.

▶ Open the scan in Photoshop (⌘O or **File**).

▶ Open the original halftone in Photoshop (⌘O or **File**).

▶ Combine the scan and the original halftone:
Select the Move tool and drag the original halftone onto the scan. *A new layer is generated containing the original image.*

▶ Modify the transparency of the original image:
Double-click on the image layer thumbnail to open the Layer Style dialog box.
This layer: Hold down the Option key and drag the left side of the white slider. *This controls which pixel values are blended.*

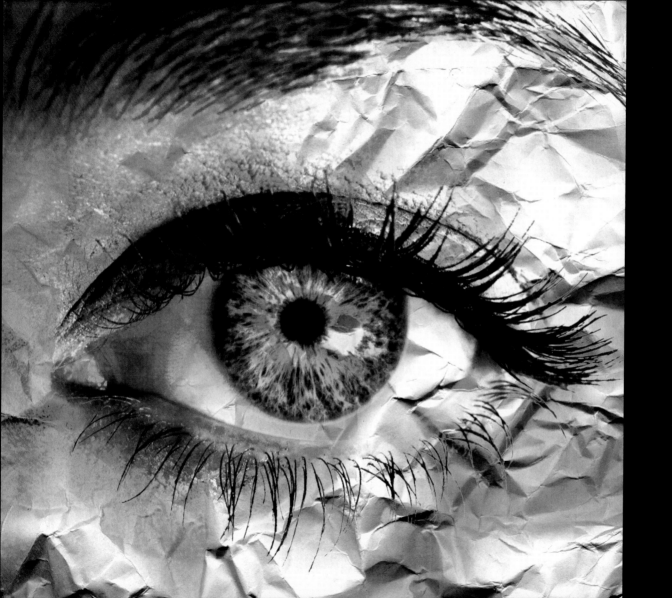

Wrinkled Line Art

▶ Open the original halftone in Photoshop (⌘O or **File**).

▶ Open the Threshold dialog box (**Image>Adjust**).
Threshold Level: 40

▶ Scan a crumpled piece of paper. Make the file the same size and resolution as the original halftone.

▶ Select the Move tool and shift-drag the scan onto the original image. *A new layer is generated containing the scan.*

▶ Open the Threshold dialog box (**Image>Adjust**).
Threshold Level: 175

▶ Show the Layers palette (**Window**).

▶ Modify the transparency of the scan layer:
Double-click on the image layer thumbnail to open the Layer Style dialog box.
This layer: Black slider: 0 White slider: 140

▶ Duplicate the scan layer and invert the tones (⌘I or **Image>Adjust**).

▶ Modify the transparency of the duplicate layer:
Double-click on the image layer thumbnail to open the Layer Style dialog box.
This layer: Black slider: 115 White slider: 255

▶ Select the Move tool and offset the duplicate layer slightly.

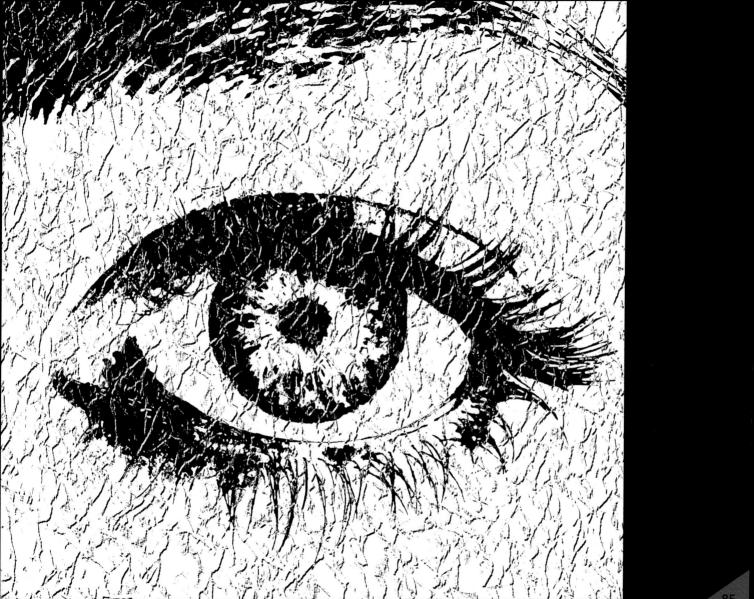

Type as Image

▶ Open the original halftone in Photoshop (⌘O or **File**).

▶ Open the Brightness/Contrast dialog box (⌘B or **Image>Adjust**). **❶**
 Brightness: 60 Contrast: 100

▶ Select All (⌘A or **Select**), and cut (⌘X or **Edit**) the image.

▶ Show the Channels palette (**Window**). **❷**
 Create a new channel. Paste the halftone into the channel (⌘V or **Edit**).

▶ Target the Gray channel.

▶ Fill the image window with black type. *A new layer is generated containing the type.*

▶ Flatten the image (**Layer**).

▶ Invert the image (⌘I or **Image>Adjust**).

▶ Use the Load Selection command to load the saved selection (**Select**).

▶ Invert the image (⌘I or **Image>Adjust**).

▶ Select the Bitmap mode option (**Image>Mode**). **❸**
 Output: 300 pixels/inch Method: 50% Threshold

Earth Texture

▶ Open the original halftone in Photoshop (⌘O or **File**).

▶ Open the Brightness/Contrast dialog box (**Image>Adjust**).
 Brightness: 60 Contrast: 100

▶ Select All (⌘A or **Select**), and copy (⌘C or **Edit**) the image.

▶ Scan an image of parched earth in grayscale. Make sure this file is the same size and resolution as the original halftone.

▶ In the scanned image, show the Channels palette (**Window**).
 Create a new channel. Double-click on the channel icon to open the Channel Options dialog box. ❷ Name the new channel "Texture."
 Opacity: 50%

▶ Paste the image from the Clipboard (⌘V or **Edit**).

▶ Invert the image (⌘I or **Image>Adjust**).

▶ Target the Gray channel. Use the Load Selection command to load the saved selection (**Select**).

▶ Invert the image (⌘I or **Image>Adjust**).

▶ Open the Levels dialog box (⌘L or **Image>Adjust**). ❸
 Input Levels: Black: 123 Gamma (midtone): 1.00 White: 255

▶ Drop the selection (⌘D or **Select**) and select the CMYK mode option (**Image>Mode**).

▶ Open the Hue/Saturation dialog box (⌘U or **Image>Adjust**). ❹
 Select Colorize and use the sliders to adjust the image.
 Hue: 10 Saturation: 50 Lightness: 15

Solarizations

Solarization effects can be created in the photographic lab by inverting tonal values from the positive to the negative. On the computer, such solarization effects can also be generated by swapping and shifting tonal values.

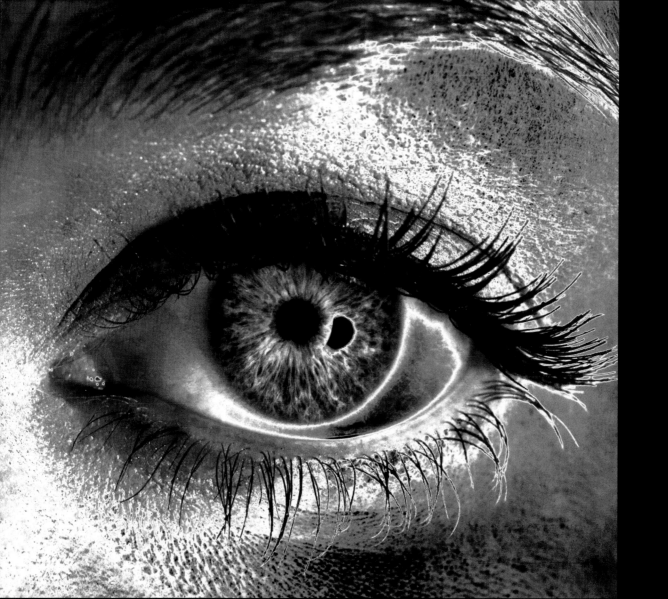

Pseudo Solarization

▶ Open the original halftone in Photoshop (⌘O or **File**).

▶ Open the Curves dialog box (⌘M or **Image>Adjust**). ❶

▶ Adjust the Curves as shown or until the desired effect is achieved.

❶

▶ *Page 91: **Solarization***
*Open the original halftone in Photoshop (⌘O or **File**).*
*Apply the Solarize filter (**Filter>Stylize**).*
*Apply the Auto Levels command to the solarized image (**Image>Adjust**).*

Tonal Composites

▶ Open the original halftone in Photoshop (**⌘O** or **File**).

▶ Show the Layers palette (**Window**).

▶ Duplicate the Background layer.
 Shortcut: Drag the current layer onto the New Layer icon.

▶ Open the Threshold dialog box (**Image>Adjust**). ❶
 Threshold Level: 80

▶ Select the white areas of the image using the Color Range dialog box (**Select**). ❷
 Fuzziness: 200

▶ Press **Delete** to clear the white areas.
 Drop the selection (**⌘D** or **Select**).

▶ Invert the layer (**⌘I** or **Image>Adjust**).

▶ Duplicate the Background layer again and open the Threshold dialog box
 (**Image>Adjust**). ❸
 Threshold Level: 25

▶ Move the second duplicate layer to the top of the Layers palette, above the first
 duplicate.

▶ Select the white areas of the image using the Color Range dialog box (**Select**). ❹
 Fuzziness: 200

▶ Press **Delete** to clear the white areas.
 Drop the selection (**⌘D** or **Select**).

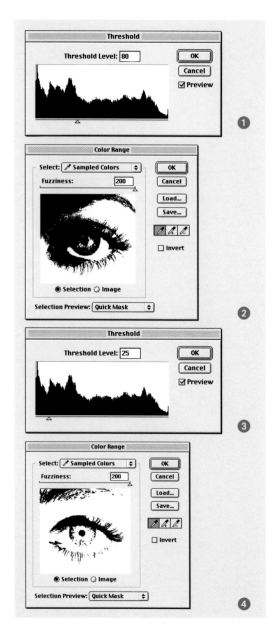

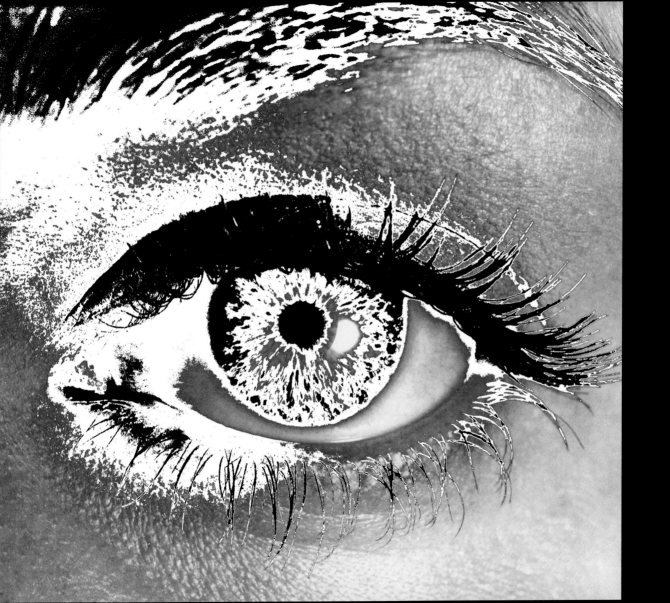

Colored Solarization

▶ Open the original halftone in Photoshop (⌘O or **File**).

▶ Select the RGB mode option (**Image>Mode**).

▶ Open the Curves dialog box (⌘M or **Image>Adjust**).
 Channel: Red (⌘1)
 Click on the curve and adjust it accordingly.
 Altering the Red channel tints the image and automatically shifts the Green and Blue channel curves.

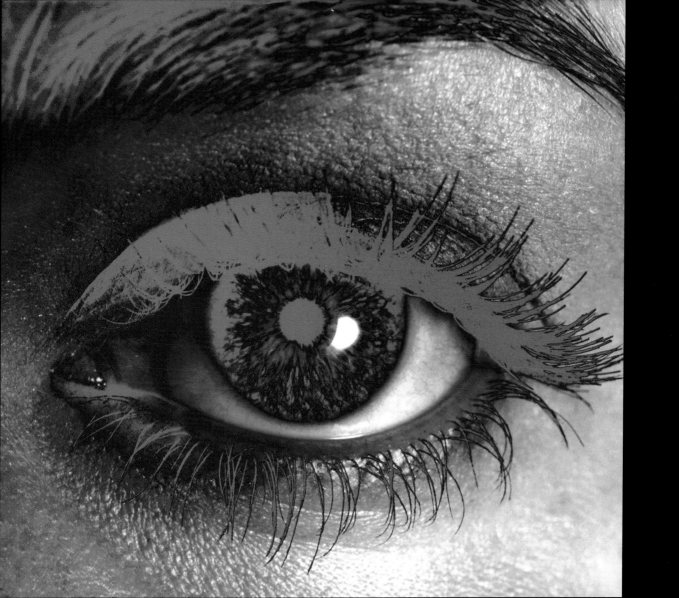

Color Bleed

▶ Open the original halftone in Photoshop (⌘O or **File**).

▶ Select the Indexed Colors mode option (**Image>Mode**).

▶ Open the Color Table dialog box (**Image>Mode**). ❶
 Table: Grayscale
 Select a group of squares (values).
 Choose a first color from the Color Picker. ❷
 Choose a last color from the Color Picker. ❸

▶ Repeat the process for additional grayscale ranges.

To create a solarization effect, select darker colors for the lighter gray areas and lighter colors for the darker gray areas.

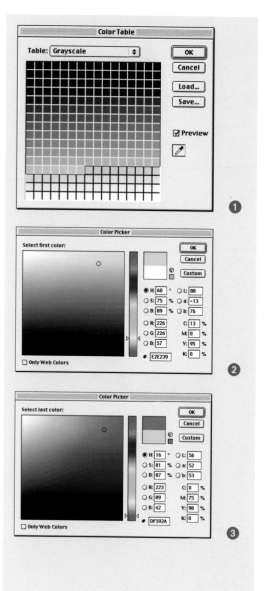

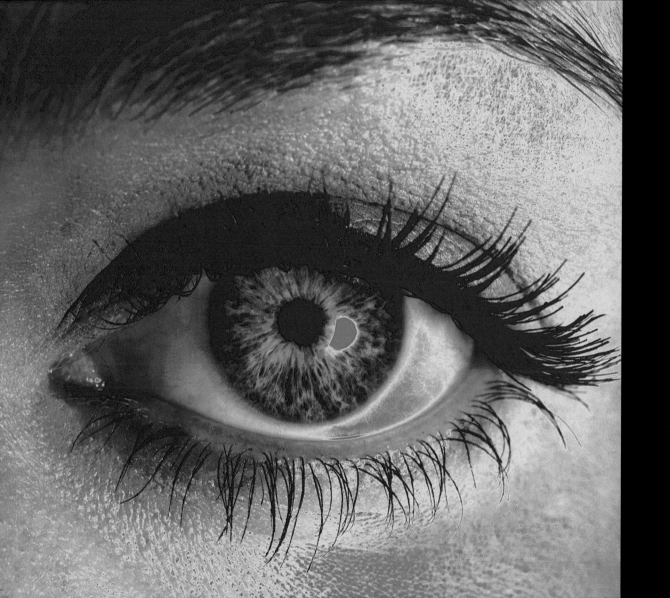

Colorizations

Colorizing black-and-white images on the computer uses much the same technique as chemical colorization methods: either the black image areas are converted into colors and the white background remains the same, or the other way around. Using various combinations of these techniques can substantially increase the effectiveness of black-and-white subjects.

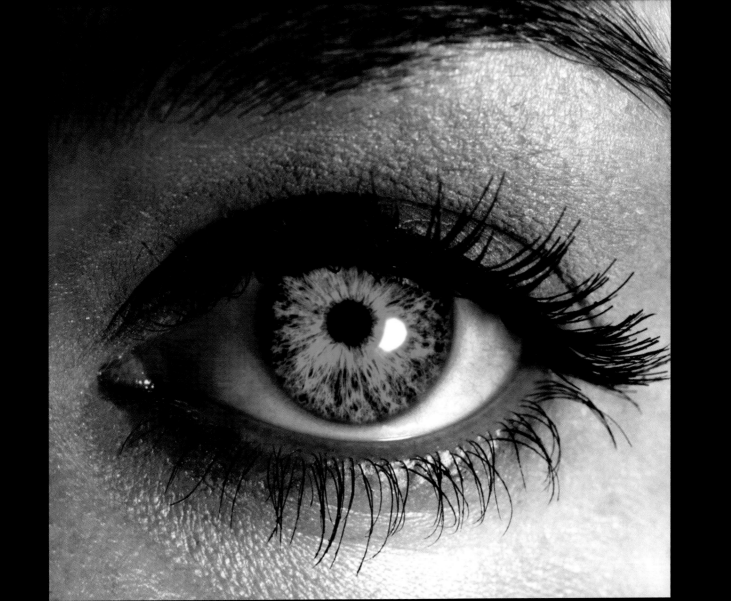

Monochromatic Colorization

▶ Open the original halftone in Photoshop (**⌘O** or **File**).

▶ Select the RGB mode option (**Image>Mode**).

▶ Select a foreground color:
Click on the Foreground color swatch on the Tool palette
or select a color from the Swatches palette.

▶ Apply a fill (**Edit**). ❶
Shortcut: **Shift Delete** *opens the Fill dialog box.*
Use: Foreground Color Opacity: 100% Mode: Color

▶ *Page 101:* **Selective Colorization**
Open the original halftone in Photoshop (⌘O *or* **File***).*
*Select the CMYK mode option (***Image>Mode***).*
Select the Elliptical Marquee tool. ❷
Use the Marquee tool to select the iris of the eye.
Feather the selection. ❸
Feather Radius: 5 pixels
Open the Hue/Saturation dialog box (⌘U *or* **Image>Adjust***).* ❹
Select Colorize and use the sliders to adjust the color.
Hue: 110 Saturation: 100 Lightness: 0

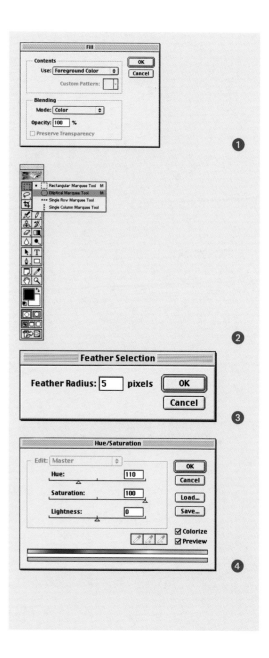

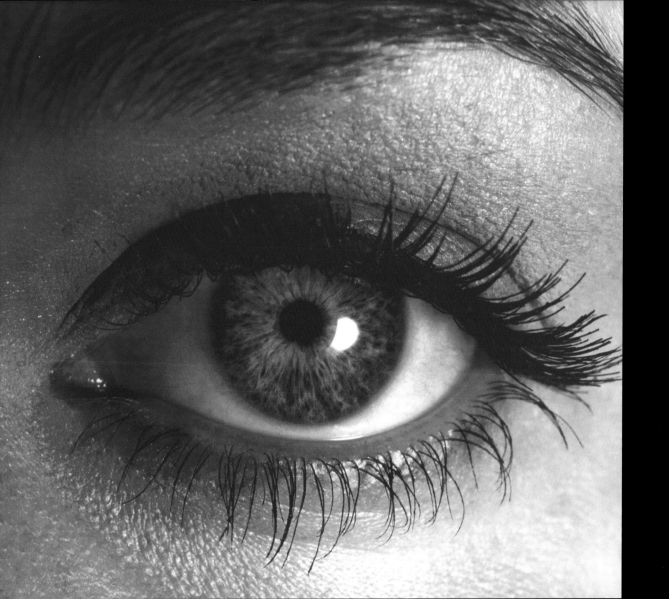

Colorizing Halftones as Line Art

▶ Open the original halftone in Photoshop (⌘O or **File**).

▶ Select the Indexed Colors mode option (**Image>Mode**).

▶ Open the Color Table dialog box (**Image>Mode**). ➊
 Table: Grayscale
 Select all the squares (values).
 Choose a first color from the Color Picker. ➋
 Choose a last color (white) from the Color Picker. ➌

▶ Select the RGB mode option (**Image>Mode**).

▶ Duplicate the Background layer and open the Threshold dialog box
 (**Image>Adjust**). ➍
 Threshold Level: 156

▶ Select the white areas of the image using the Color Range dialog box (**Select**). ➎
 Fuzziness: 200

▶ Press **Delete** to clear the white areas.
 Drop the selection (⌘D or **Select**).

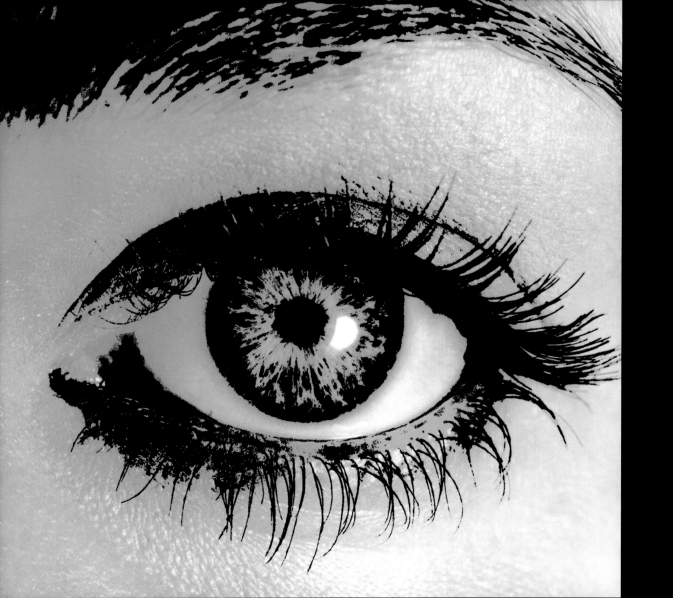

Colorizing Halftones

▶ Open the original halftone in Photoshop (**⌘O** or **File**).

▶ Select the RGB mode option (**Image>Mode**).

▶ Open the Brightness/Contrast dialog box (**Image>Adjust**). **❶**
 Brightness: 0 Contrast: 20

▶ Select a foreground color:
 Click on the Foreground Color swatch on the Tool palette.
 Define the color as:
 C: 0% M: 0% Y: 100% K: 0%

▶ Apply a Fill (**Edit**). **❷**
 Shortcut: **Shift Delete** *opens the Fill dialog box.*
 Use: Foreground Color
 Opacity: 100%
 Mode: Difference

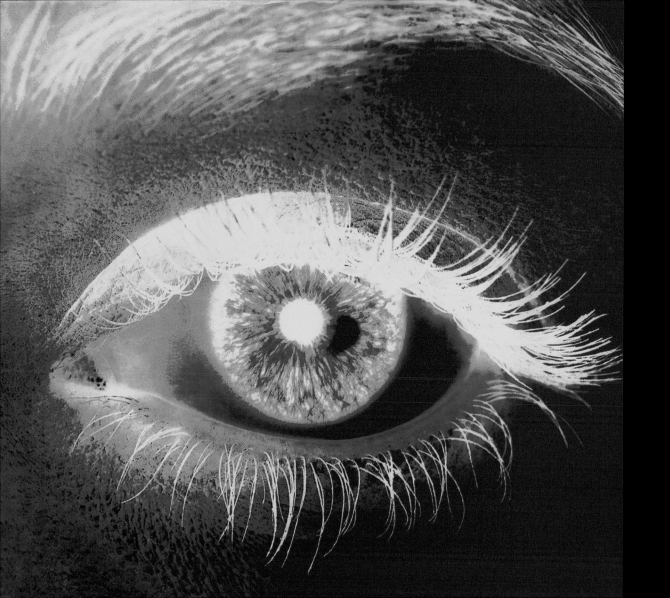

Spectral Colorizing

▶ Open the original halftone in Photoshop (⌘O or **File**).

▶ Select the CMYK mode option (**Image>Mode**).

▶ Double-click on the Gradient tool. ❶
 Style: Spectrum Type: Linear Mode: Color
 Opacity: 100% Dither Transparency
 Click and drag from the top of the image to the bottom.
 This creates a vertical gradient over the whole image.

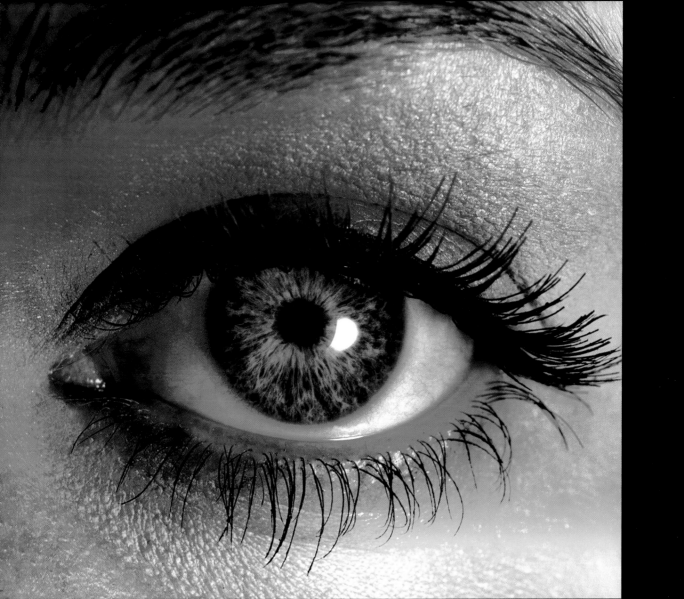

Color Gradients

▶ Open the original halftone in Photoshop (⌘O or **File**).

▶ Select the CMYK mode option (**Image>Mode**).

▶ Use the Rectangular Marquee tool to select the right third of the image.

▶ Feather the selection (**Select**).
 Radius: 200 pixels

▶ Open the Hue/Saturation dialog box (⌘U or **Image>Adjust**). ❷
 Select Colorize and use the sliders to adjust the image.
 Hue: 14 Saturation: 70 Lightness: −10

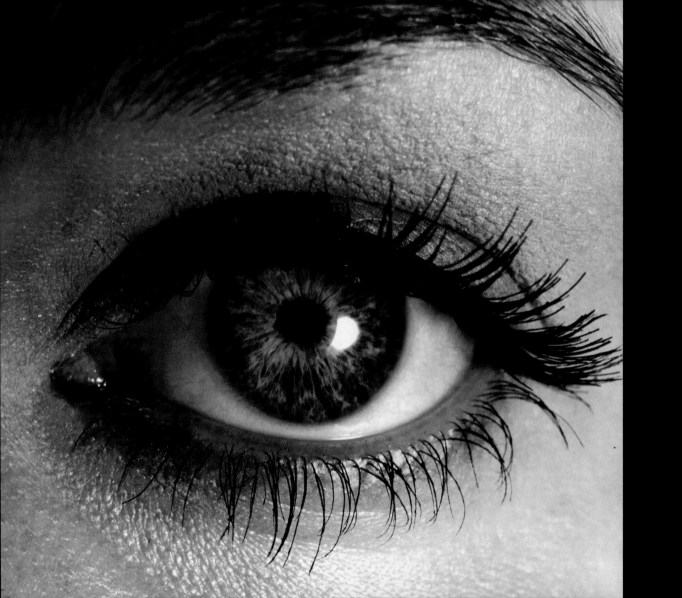

Colorizing Grain Screens

▶ Open the original halftone in Photoshop (⌘O or **File**).

▶ Select the Bitmap mode option (**Image>Mode**). ❶
 Output: 200 pixels/inch Method: Diffusion Dither

▶ Select the Grayscale mode option (**Image>Mode**).
 Size ratio: 1

▶ Apply the Crystallize filter (**Filter>Pixelate**). ❷
 Cell size: 3

▶ Select the RGB mode option (**Image>Mode**).

▶ Show the Layers palette (**Window**).
Duplicate the Background layer.
Shortcut: Drag the current layer onto the New Layer icon.

▶ Open the Hue/Saturation dialog box (⌘U or **Image>Adjust**). ❸
Select Colorize and use the sliders to adjust the image.
 Hue: 170 Saturation: 70 Lightness: 10

▶ Choose the layer's blending mode: Multiply. ❹
The Multiply mode multiplies the base color and top color, resulting in a darker color.

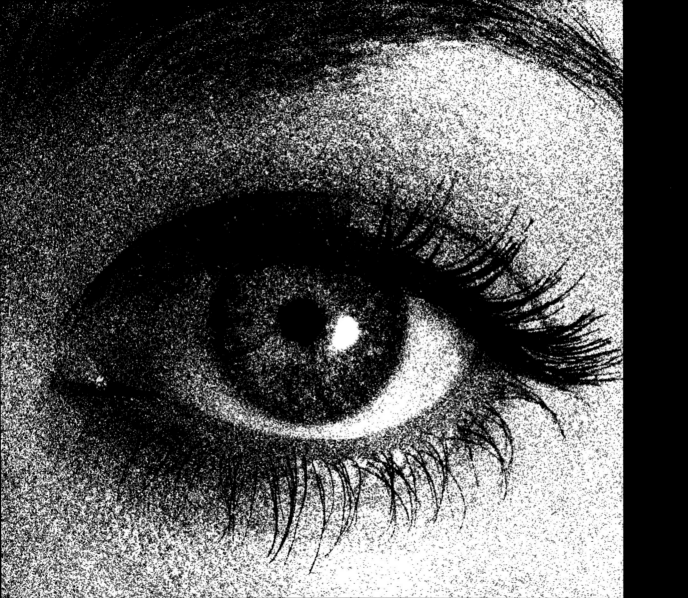

Fake Duotone

▶ Open the original halftone in Photoshop (**⌘O** or **File**).

▶ Select the CMYK mode option (**Image>Mode**).

▶ Select a Foreground Color swatch on the Tool palette. ❶
Define the color as:
 C: 0% M: 0% Y: 100% K: 0%

▶ Select All (**⌘A** or **Select**).

▶ Apply a fill (**Edit**). ❷
Shortcut: **Shift Delete** opens the Fill dialog box.
 Use: Foreground Color Opacity: 100% Mode: Multiply

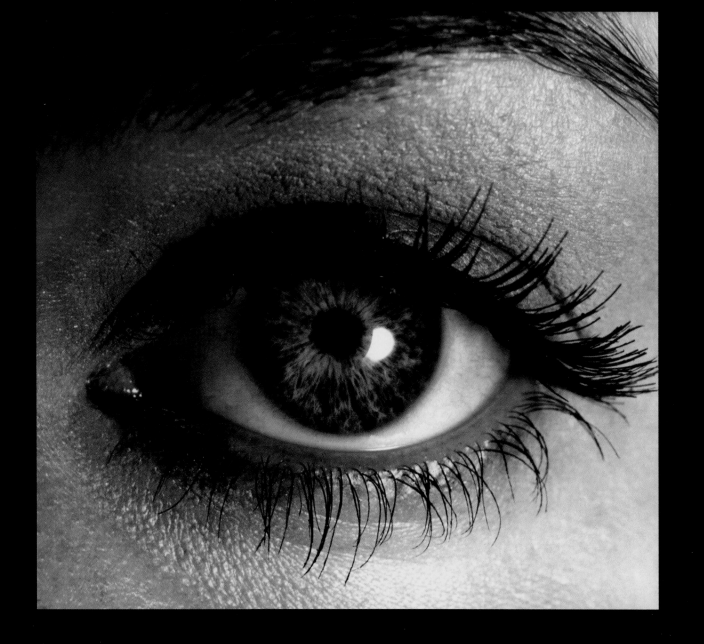

Duotone

▶ Open the original halftone in Photoshop (⌘0 or **File**).

▶ Select the Duotone mode option (**Image>Mode**).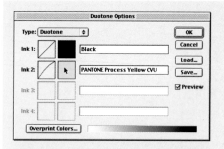
 Type: Duotone
Click on the Ink 2 swatch.
Select a yellow from the Color Picker as the second color.
Because this book was printed in a four-color process, the choices available for the second color are limited to yellow, cyan, or magenta. A duotone with a spot color is also possible, as long as it is used later in the printing process. This color can be selected using the Color Table option in the Color Picker.

▶ Click on the Ink 2 Curve icon.
Modify the light/dark distribution of the additional ink in the Duotone Curve dialog box.

▶ *Page 118:* **Tritone**
Same procedure as with Duotone.
 Type: Tritone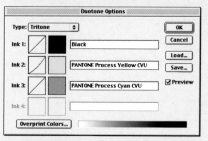
Select two additional colors (yellow and cyan) as Ink 2 and Ink 3.

▶ *Page 119:* **Quadtone**
Same procedure as for Duotone and Tritone.
 Type: Quadtone
Select three additional colors (yellow, cyan, and magenta) as Ink 2, Ink 3, and Ink 4.

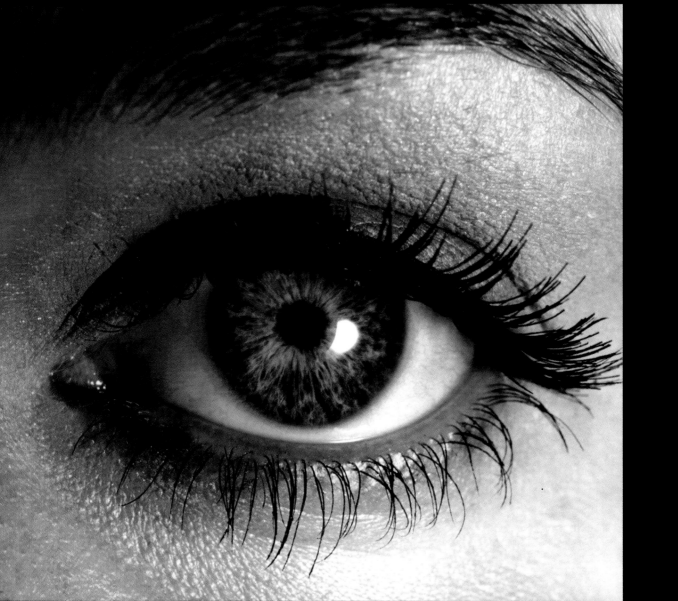

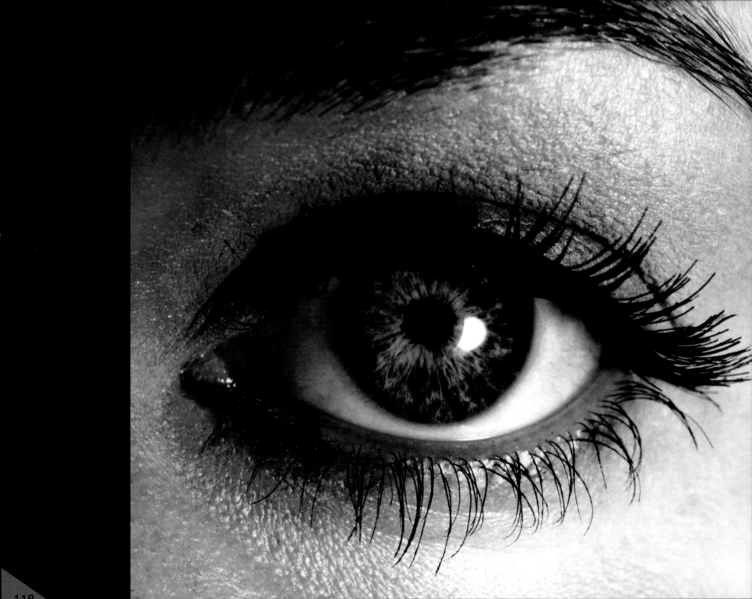

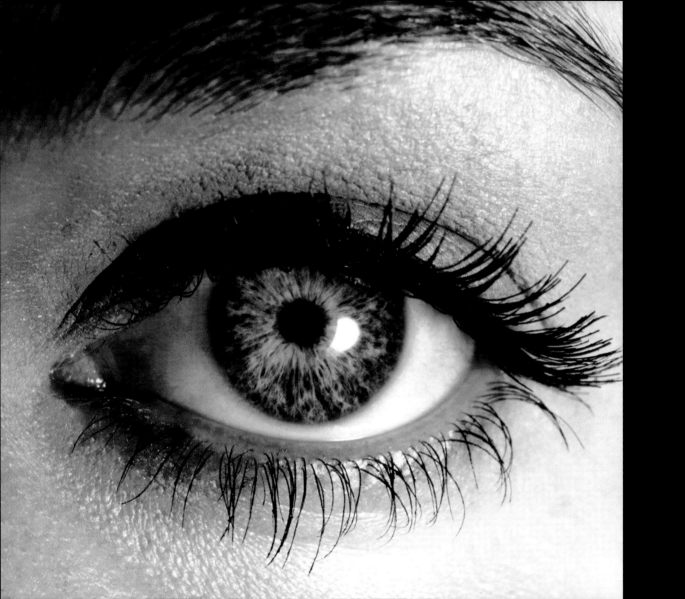

Colorizing by Hand

▶ Open the original halftone in Photoshop (⌘O or **File**).

▶ Select the RGB mode option (**Image>Mode**).

▶ Double-click the Lasso tool. ❶
 Feather: 10 pixels Anti-aliased
 Use the Lasso tool to select a region to be colorized.

▶ Define foreground and background colors:
 Click on the respective color swatches and select the desired colors within the
 Color Picker. ❷

▶ Double-click on the Gradient tool. ❸
 Style: Foreground to Background Type: Linear Mode: Color
 Opacity: 8% Dither Transparency
 Fill the marked area by dragging across it. *The colors in the gradient are determined by the
 previously selected foreground and background colors.*

▶ Repeat this procedure until the whole image is colorized.

▶ Remove imperfections and hard edges with the Airbrush tool (**J**).

▶ Save the file as "Colorizing" (**File**).
 It is used for the example on pages 156–157.

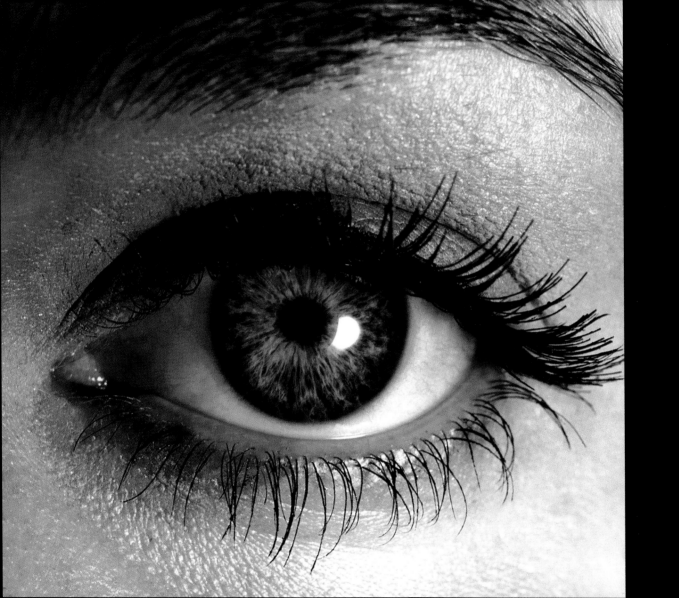

Color Overlay

- ▶ Open the original halftone in Photoshop (**⌘O** or **File**).
- ▶ Select the RGB mode option (**Image>Mode**).
- ▶ Duplicate the Background layer (**Layer**); name it "Background 1."
 Choose the Layer Blending mode: Multiply **❶**
- ▶ Apply the Spatter filter. (**Filter>Brush Strokes**). **❷**
 Spray Radius: 11 Smoothness: 5
- ▶ Create a new layer (**Layer**); name it "Color." **❸**
 Position it under the Background 1 layer.
- ▶ Use the Airbrush tool (**J**) to add color to the Color layer as desired.
 Brush: Soft round 65 pixels
 Mode: Normal
 Pressure: 25%
- ▶ Apply the Gaussian Blur filter (**Filter>Blur**). **❹**
 Radius: 55 pixels
- ▶ Duplicate the Color layer (**Layer**); name it "Color 1."
 Position it above the Background 1 layer.
 Choose the Layer Blending mode: Color Dodge.
- ▶ Delete the Background layer containing the original halftone.

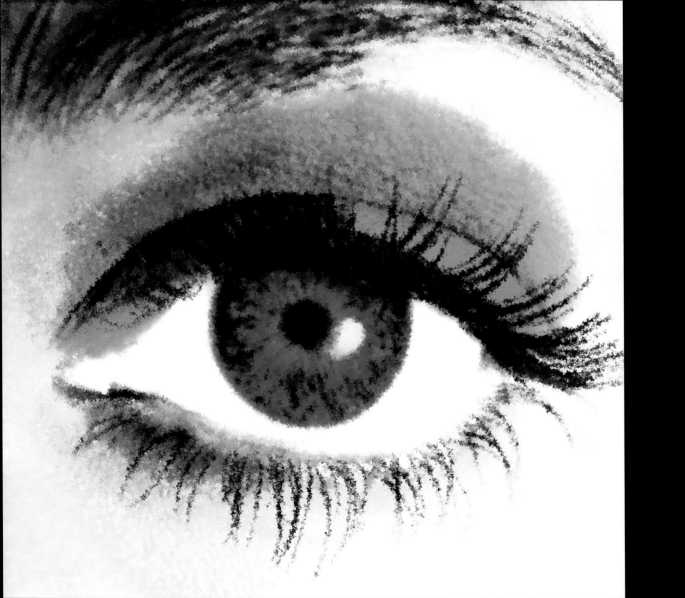

Dynamic Effects

The computer offers a wide variety of options for creating dynamic (motion) effects. Expanding the image area, using smudge effects and distortion filters, and superimposing various image sizes—along with combinations of these techniques—make the possibilities in this area seem infinite.

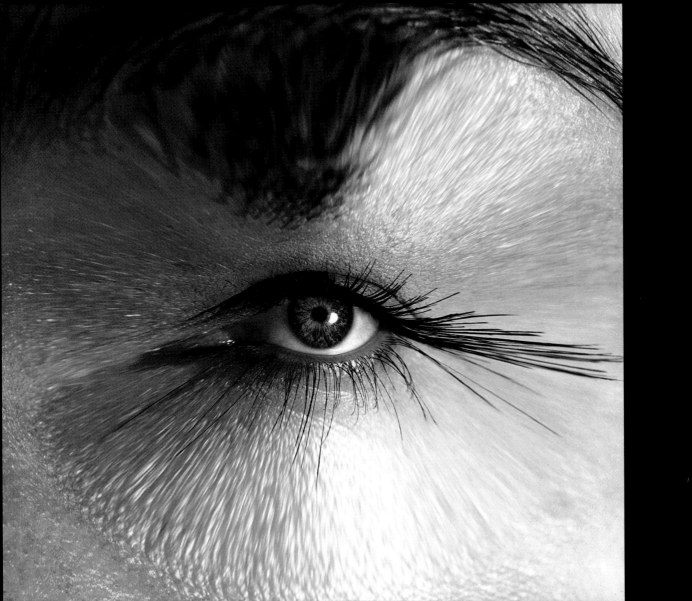

Double Distortion

- ▶ Open the original halftone in Photoshop (⌘O or **File**).
- ▶ Apply the Spherize filter (**Filter>Distort**). ❶
 Amount: –100% Mode: Horizontal only
- ▶ Apply the filter a second time.
 Shortcut: ⌘F reapplies the last filter.

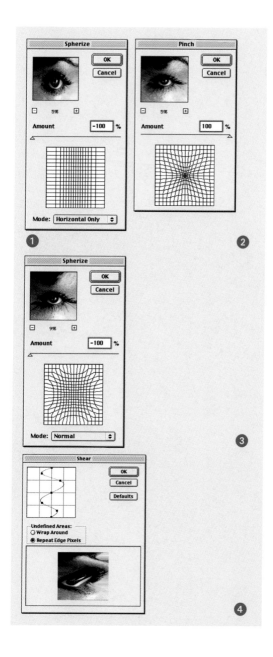

- ▶ *Page 125: **High Distortion***
 *Open the original halftone in Photoshop (⌘O or **File**).*
 *Apply the Pinch filter (**Filter>Distort**).* ❷
 Amount: 100%

- ▶ *Page 128: **Spherical Distortion***
 *Open the original halftone in Photoshop (⌘O or **File**).*
 *Apply the Spherize filter (**Filter>Distort**).* ❸
 Amount: –100% Mode: Normal

- ▶ *Page 129: **Wave Distortion***
 *Open the original halftone in Photoshop (⌘O or **File**).*
 *Apply the Shear filter (**Filter>Distort**).* ❹
 Undefined Areas: Repeat Edge Pixels
 Create and drag points along the reference line to indicate the level of distortion.

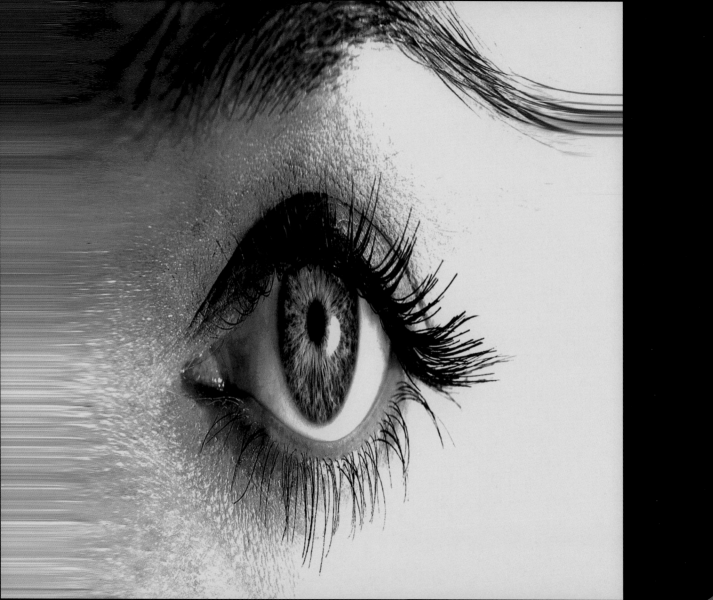

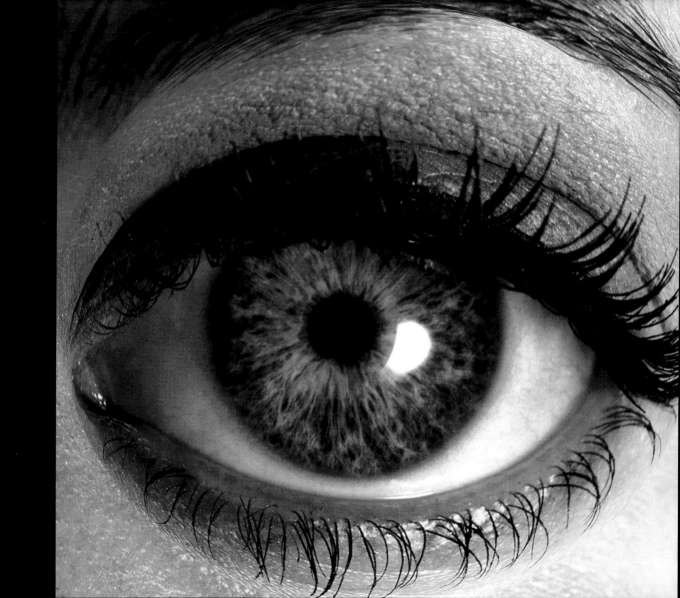

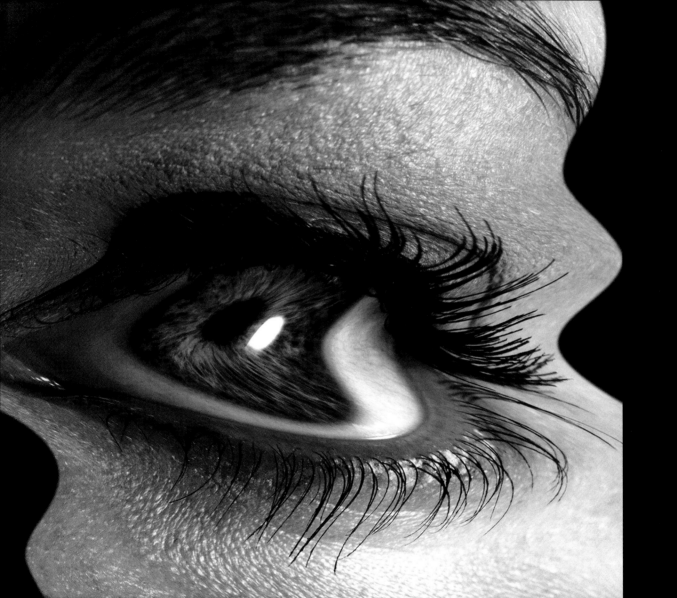

Perspective

▶ Open the original halftone in Photoshop (⌘**0** or **File**).

▶ Show the Channels palette (**Window**). Create a new channel.

▶ Use the Rectangular Marquee tool to select a square area in the alpha channel. Press **Option Delete** to fill the selection with white. Repeat, using the grid to align selections, to create a nine-square grid as shown. ❶

▶ Select the squares and scale them to fill the entire image as closely as possible (**Edit>Transform**). Select the Crop tool and crop the image so that the squares fill the entire window.

▶ Duplicate the channel and scale the copy from the center as shown (**Edit>Transform**). Repeat to create a third alpha channel with yet smaller squares. ❷
*To scale from the center of the selection, hold down **Option** while dragging the handles.*

▶ Select the RGB mode option (**Image>Mode**).

▶ Show the Layers palette (**Window**). Duplicate the Background layer three times to create three new layers.
Shortcut: To duplicate a layer, drag it on top of the New Layer button.

▶ Target the top layer and load the selection of the first alpha channel (**Select**). ❸
 Select Invert Operation: New Selection
Press **Delete**.
Repeat with the next layer down and the second alpha channel, then with the third layer down and the third alpha channel.

▶ Select each layer in turn and open the Hue/Saturation dialog box (⌘**U** or **Image>Adjust**). ❹ Select Colorize and use the sliders to adjust the image.
 Hue: 194 Saturation: 60 Lightness: 0

▶ Select All (⌘**A** or **Select**). Transform the selection by scaling it from the center (**Option**). Invert the selection (⌘**I** or **Select**) and press **Option Delete** to fill the selection with black.

▶ *Page 132: Overlay*
*Open the original halftone in Photoshop (⌘**0** or **File**). Duplicate the Background layer several times. Moving from the bottom of the Layers palette to the top, target each layer in turn, select All (⌘**A** or **Select**), and scale from the center (**Edit>Transform**) by holding down **Option** while dragging.*

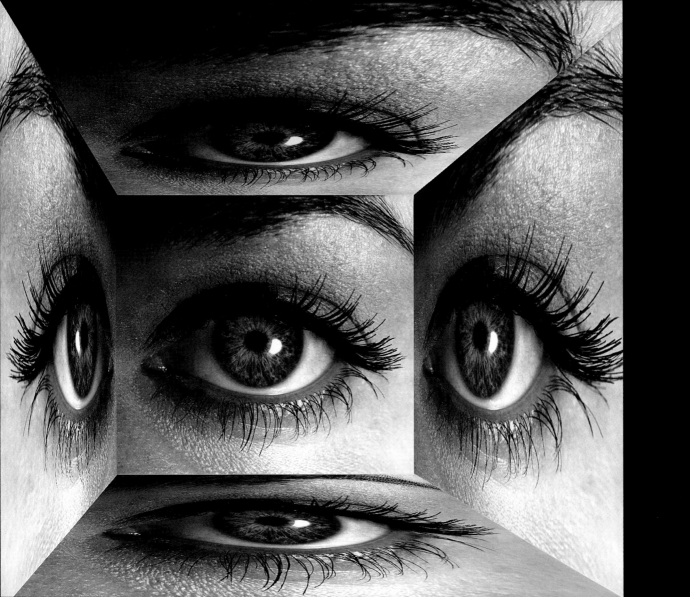

Rotation

▶ Open the original halftone in Photoshop (⌘O or **File**).

▶ Show the Channels palette (**Window**).
Create a new channel; name it "Spiral." Press **D** to set the default foreground and background colors. Press **X** to swap the default colors. Use the Line tool to draw a cross in the channel. ❶
 Line width: 150 pixels

▶ Apply the Twirl filter (**Filter>Distort**). ❷
 Angle: 650°

▶ Apply the Gaussian Blur filter (**Filter>Blur**). ❸
 Radius: 5 pixels

▶ Target the Gray channel.
Use Load Selection to load the Spiral channel (**Select**). ❹
Open the Curves dialog box (⌘M or **Image>Adjust**). ❺
Adjust the curve to darken the selection.

▶ Use the Elliptical Marquee tool to select a circular area in the middle of the eye. Invert the selection (**Select**) and apply a Feather (**Select**). ❻
 Feather Radius: 100 pixels

▶ Define black as the background color.
*Shortcut: Click the Default colors button (**D**), then the Switch colors toggle (**X**). Delete the selection by pressing* **Delete**.

▶ *Page 133:* **Perspective Distortion**
*Open the original halftone in Photoshop (⌘O or **File**). Duplicate the Background layer four times. Show guides (**View>Show**) and use guides to define a box slightly offset from the center of the image. Target any layer, select All (⌘A or **Select**), and use Free Transform (holding down Option while dragging) to move two corners of the image to two corners of the center box (⌘T or* **Edit>Transform**). *Repeat with three more layers to form the sides of the image. Use Free Transform to move all four corners of the remaining layer to the four corners of the center box (⌘T or* **Edit>Transform**).

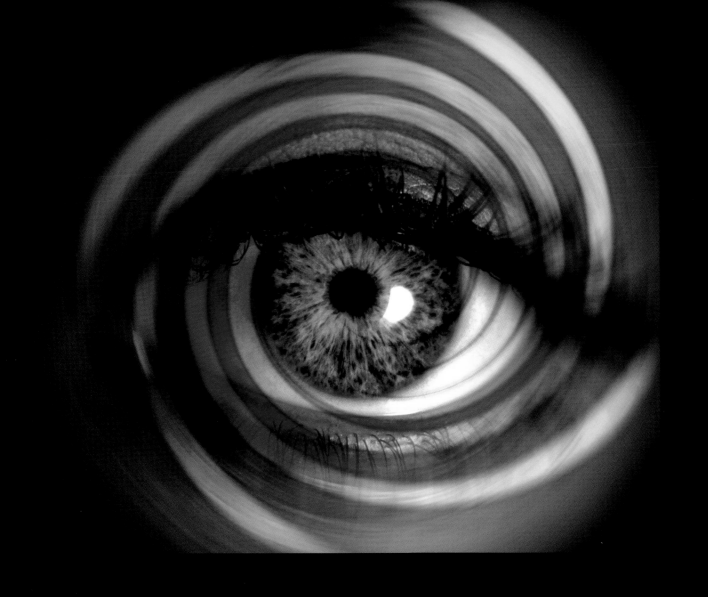

Perspective Lines

▶ Open the original halftone in Photoshop (**⌘O** or **File**). Select the RGB mode option (**Image>Mode**).

▶ Select a blue foreground and yellow background color. Click on the respective color swatch in the Tool palette and select desired color within the Color Picker.

▶ Double-click on the Gradient tool. ❶
 Style: Foreground to Background Type: Linear Mode: Color
 Opacity: 25% Dither Transparency
 Drag from the lower left to the upper right of the image.

▶ Show the Layers palette. ❷
 Create a new layer. Change its blending mode to Lighten.

▶ Show the Paths palette (**Window**). Select the Pen tool and draw a line pattern as shown. ❸
 Select the Path Component Selection tool and select All (**⌘A** or **Select**).

▶ Switch to the Pencil tool, choose a brush of the appropriate width, and stroke the paths (**Paths palette menu>Stroke**).

▶ *Page 138:* ***Motion Blur***
 *Open the original halftone in Photoshop (**⌘O** or **File**).*
 *Apply the Motion Blur filter (**Filter>Blur**).* ❹
 Degrees: 24 Distance: 50
 *Apply the Sharpen More filter (**Filter>Sharpen**).*
 *Select the CMYK mode option (**Image>Mode**). Open the Hue/Saturation dialog box (**⌘U** or* ***Image>Adjust***).
 Select Colorize and use the sliders to adjust the image.
 Hue: 13 Saturation: 100 Lightness: 0

▶ *Page 139:* ***Pyramid Effect***
 *Open the original halftone in Photoshop (**⌘O** or **File**).*
 *Apply the Extrude filter (**Filter>Stylize**).* ❺
 Type: Pyramids Size: 35 pixels Depth: 40 Random

Negative Shadow Blur

▶ Open the original halftone in Photoshop (⌘O or **File**).

▶ Select the RGB mode option (**Image>Mode**).

▶ Duplicate the Background layer (**Layer**); name it "Background 1."

▶ Open the Levels dialog box (⌘L or **Image>Adjust**).
 Input: Black: 0 Gamma (midtone): 0.10 White: 59 **1**

▶ Create a new layer (**Layer**); name it "Color."

▶ Using the Paint tools, add color to the Color layer as desired.

▶ Apply the Color Range command to select all of the black in the Background 1 layer (**Select**). **2**
 Select: Shadows

▶ Target the Color layer and clear the selected area (**Edit**).
 Shortcut: Press the **Delete** key to clear the selection.

▶ Drop the selection (⌘D or **Select**).

▶ Target the Background 1 layer. Select All (⌘A or **Layer**).

▶ Apply the Invert command to create a negative (**Image>Adjust**).
 Choose the Layer Blending mode: Multiply (**Layers palette**). **3**

▶ Select bottom half of the image with the Rectangular Marquee tool.
 Feather: 40 pixels

▶ Apply the Motion Blur filter (**Filter>Blur**). **4**
 Angle: 90° Distance: 180 pixels

▶ Delete the Background layer containing the original halftone.

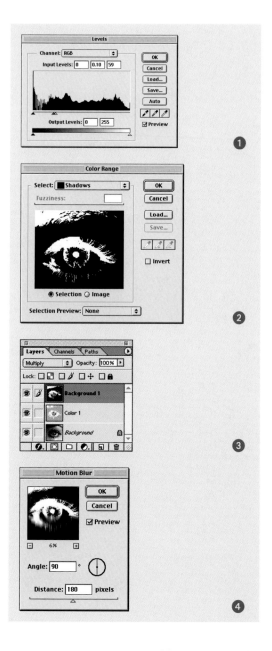

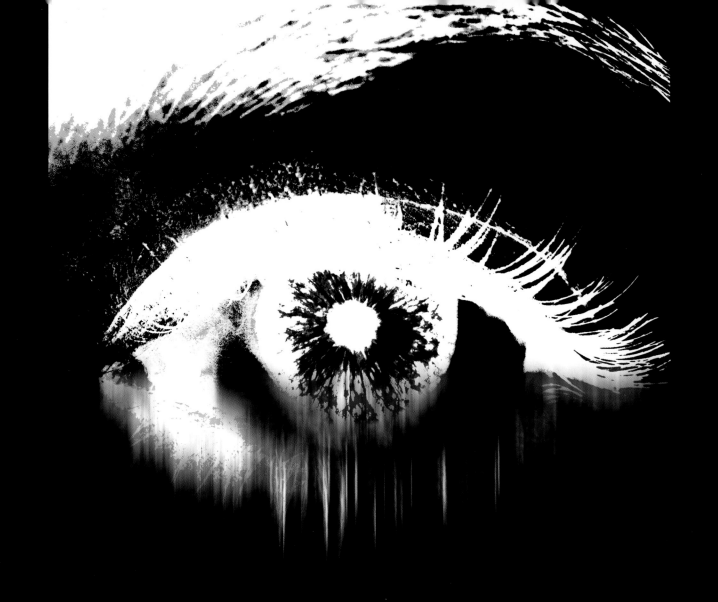

Offset Tiles

▶ Open the original halftone in Photoshop (⌘O or **File**).

▶ Duplicate the Background layer (**Layer**); name it "Background 1." ❶

▶ Use the Elliptical Marquee tool to select the eye.

▶ Invert the selection (**Select**).

▶ Apply the Tiles filter (**Filter>Stylize**). ❷
 Number of Tiles: 15
 Maximum Offset: 8%
 Fill Empty Area With: Inverse Image

▶ Drop the selection (⌘D or **Select**).

Combining various image elements into a new image used to require technical know-how and extreme precision. The versatile montage and masking options offered by Photoshop considerably ease the task of creating such compositions. The program allows fast exchanges, shifts, modifications, rotations, or combinations of individual elements, making it easy to create completely new images.

Stripe Montage

▶ Open the original halftone in Photoshop (**⌘O** or **File**).

▶ Show the Layers palette (**Window**). Duplicate the Background layer and target the duplicate.
Shortcut: To duplicate the Background layer, drag it on top of the New Layer button.

▶ Check the image size (**Image**). ❶
Divide the height of the image in pixels (1831) by 13, then round up to the nearest whole number—in this case, 141.

▶ In the Guides & Grid preferences, set the gridlines to appear every 141 pixels (**Edit>Preferences**). ❷
Use the number you obtained in the previous step.

▶ Double-click on the Rectangular Marquee tool in the Tool palette and choose Fixed Size from the Style menu. ❸
 Width: 3000 Height: 141

▶ Show the grid (**View>Show**). Click at the top of the image to select the area of the first stripe, then Shift-click at every other gridline to select the other six stripes.

▶ Click the Create Layer Mask button on the Layers palette to turn the selection into a layer mask for the duplicate layer. ❹

▶ Target the Background layer and invert it (**⌘I** or **Image>Adjust**).

▶ *Page 145: **Positive-Negative Montage***
*Open the original halftone in Photoshop (**⌘O** or **File**).*
Reduce the image's tonal range:
*Use the Threshold command (**Image>Adjust**). ❺*
Drag slider to the desired threshold level.
 Threshold Level: 60
Use the Rectangular Marquee tool to select the right half of the image.
*Invert the selected area (**⌘I** or **Image>Adjust**).*

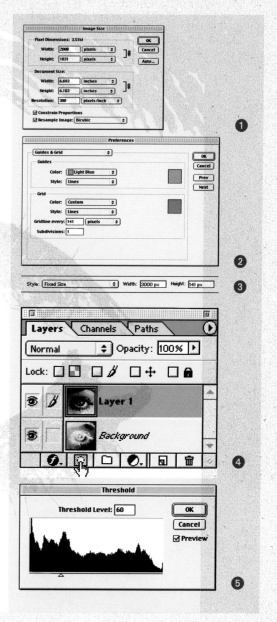

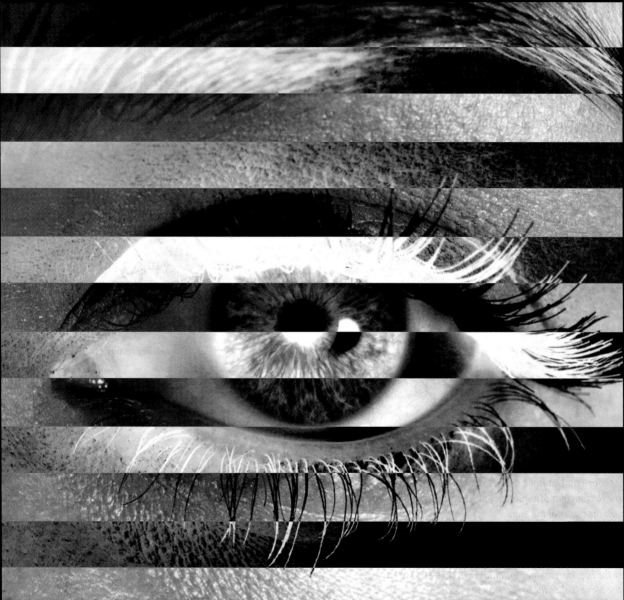

Stencils

▶ Open the original halftone in Photoshop (**⌘O** or **File**).

▶ Define black as the background color. **①**
*Shortcut: Click the Default colors button (**D**), then the Switch colors toggle (**X**).*

▶ Select All (**⌘A** or **Select**) and press **Delete**.

▶ Double-click on the Eraser tool in the Toolbox. **②**
Mode: Block Erase to History
Click OK. *This allows you to erase the black back to the original saved version, as you click with the Eraser. The size of the eraser block is determined by the zoom level—zoom in on the image to erase smaller blocks.*

▶ *Page 150:* **Reflections**
*Open the original halftone in Photoshop (**⌘O** or **File**).*
Use the Rectangular Marquee tool to select the left half of the image. Make sure the selection cuts through the center of the pupil.
*Feather the selection (**Select**).* **③**
 Radius: 10 pixels
*Create a new layer by copying the selection (**⌘J** or **Layer>New**).*
*Apply the Flip Horizontal command (**Edit>Transform**).* **④**
Use the Move tool or the arrow keys to match the selected area with its mirror image.

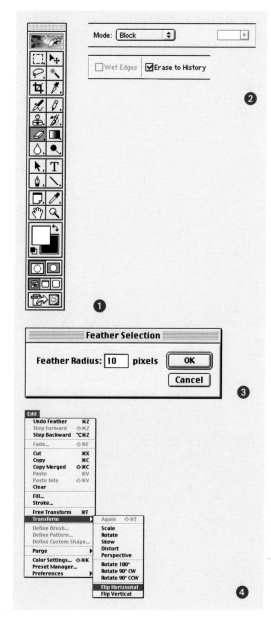

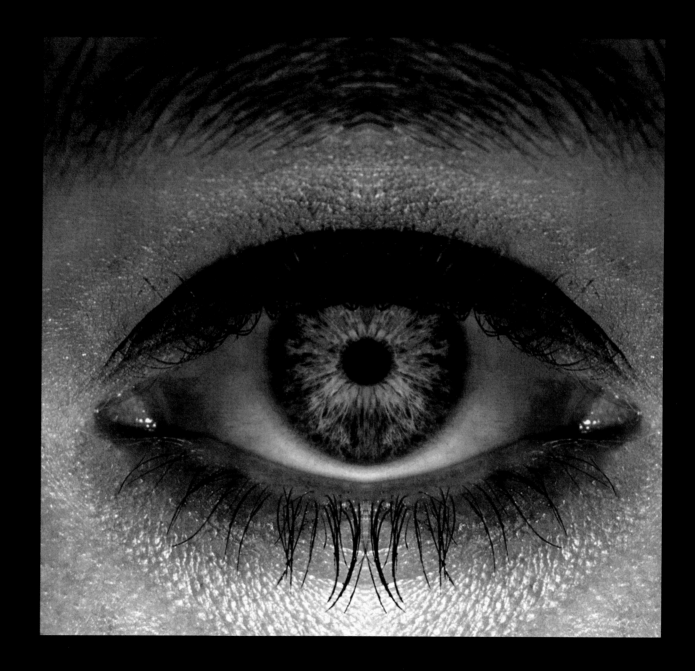

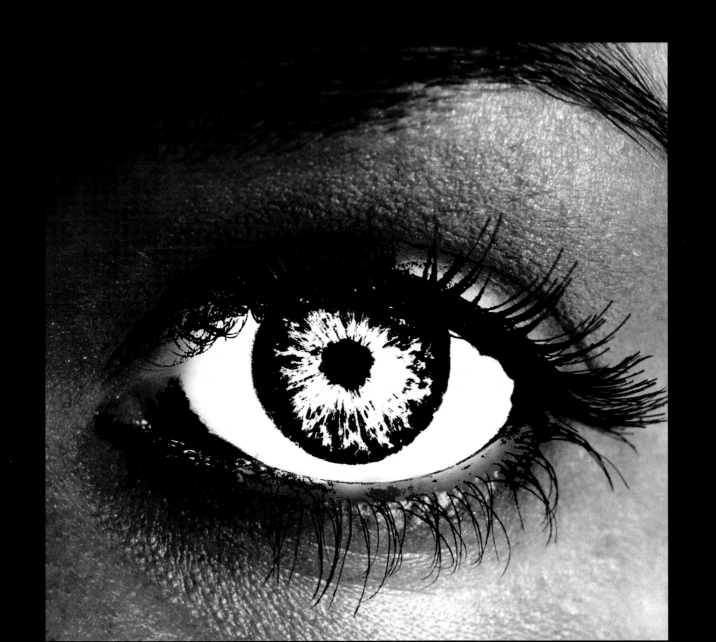

Combining Subjects

▶ Scan a black-and-white picture of a camera. Make the file the same size and resolution as the original halftone. Open the camera scan in Photoshop (⌘O or File).

▶ Apply the Spherize filter (**Filter>Distort**). ❶
 Amount: 100% Mode: Normal

▶ Select the camera, leaving the background out of the selection.
 To add to your selection, hold down the **Shift** *key. To subtract from your selection, hold down the* **Option** *key.*

▶ Open the original halftone in Photoshop (⌘O or **File**).

▶ Select the Move tool and drag the camera onto the original halftone.

▶ Scale the camera image down to fit within the eye's iris:
 Choose the Scale command (**Image>Transform**).
 Click and drag one handle toward the center to shrink the image. Hold the **Shift** key to constrain the image proportions.

▶ Apply the Gaussian Blur filter (**Filter>Blur**). ❷
 Radius: 3 pixels

▶ Choose Add Layer Mask from the Layers palette pop-up menu. The layer mask preview will appear. Make black the foreground color. Use the Paintbrush tool to mask out desired areas of the camera.

▶ *Page 151:* **Line Art–Halftone Montage**
 Open the original halftone in Photoshop (⌘O or **File***).*
 Double-click the Lasso tool. ❸
 Feather: 15 pixels Anti-aliased
 Use the Lasso tool to select an area of the image (in our example, the eyeball).
 Open the Brightness/Contrast dialog box (**Image>Adjust***).* ❹
 Brightness: 0 Contrast: 95
 Invert the selection (**Select***).*
 Darken the image midtones slightly:
 Open the Levels dialog box (⌘L or **Image>Adjust***).* ❺
 Decrease the gamma (midtone) Input Levels by moving the gamma (middle) slider to the right.
 Input Levels: Black: 0 Gamma (midtone): 0.6 White: 255

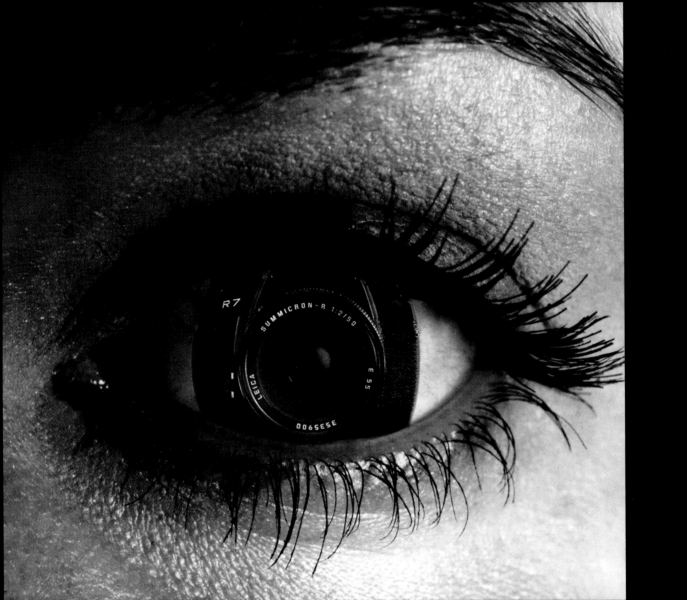

Masking

▶ Open the original halftone in Photoshop (**⌘O** or **File**).

▶ Show the Layers palette (**Window**). Duplicate the Background layer. Fill the Background with black (**Edit**). ❶
 Use: Black Opacity: 100% Mode: Normal

▶ Target the duplicate layer and choose Add Layer Mask from the Layers palette pop-up menu. Click on the layer mask icon in the Layers palette.

▶ Double-click the Lasso tool. ❷
 Feather: 10 pixels Anti-aliased
Use the Lasso tool to create the trapezoidal section of the keyhole.
Holding the **Option** *key draws straight lines.*

▶ Use the Elliptical Marquee tool to create the circular section of the keyhole.
Press **Shift M** *to switch from the Rectangular Marquee tool
to the Elliptical Marquee tool and back.*

▶ Feather the selection (**Select**). ❸
 Radius: 30 pixels

▶ Invert the selection (**Select**).

▶ Fill the selection with black (**Edit**). ❶
 Use: Black Opacity: 100% Mode: Normal

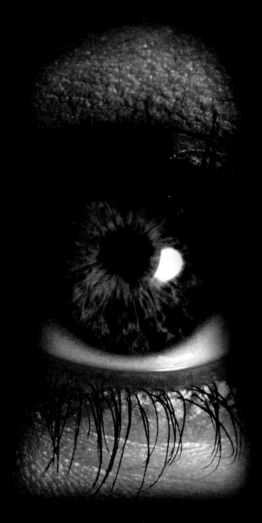

Partial Blur

▶ Open the Colorizing by Hand file (page 120) in Photoshop (⌘O or **File**).

▶ Click on the Quick Mask mode in the Toolbox.

▶ Make black the foreground color.

▶ Use the Paintbrush tool to mask desired areas of the image.
A red overlay (akin to a rubylith) will appear.
Toggle back to Standard selection mode.
*Shortcut: The **Q** key toggles between Standard selection mode and Quick Mask mode.*

▶ Apply the Gaussian Blur filter (**Filter>Blur**). ❶
Radius: 15 pixels

▶ Open the Curves dialog box (⌘M or **Image>Adjust**). ❷
Lighten the image by adjusting the curve accordingly.

▶ Increase the amount of Cyan in the image:
Choose the Variations command (**Image>Adjust**). ❸
Click on the More Cyan thumbnail image once.
Click OK.

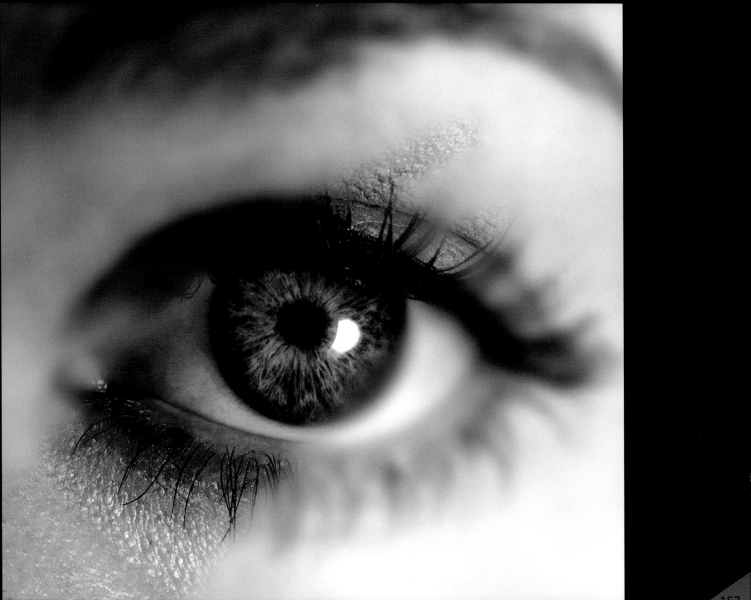

Structure Mask

▶ Scan an image of a brush stroke in black and white. Make the file the same size and resolution as the original halftone. ❶

▶ Open the brush stroke scan in Photoshop (⌘O or **File**).

▶ Open original halftone in Photoshop (⌘O or **File**).

▶ Use the Move tool to drag the brush stroke image onto the original halftone.

▶ Invert the image (⌘I or **Image>Adjust**).

▶ Show the Layers palette (**Window**). Choose the Layer Blending mode: Darken. ❷

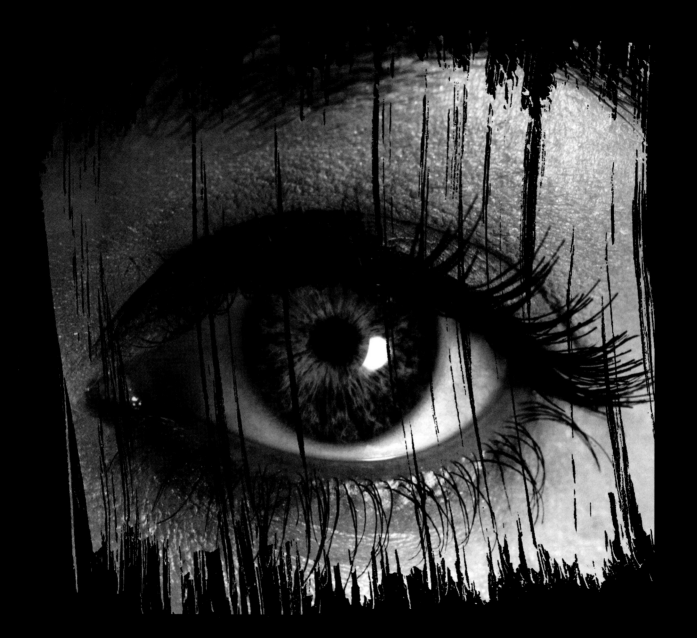

Collage

▶ Open the original halftone in Photoshop (⌘O or **File**).

▶ Select the CMYK mode option (**Image>Mode**).

▶ Select a white foreground and yellow background color:
Click on the respective color swatch and select the desired color
within the Color Picker. ❶

▶ Use the Marquee tool to select a rectangular stripe across the image. Offset it by
switching to the Move tool and dragging with the mouse.
Shortcut: Press U to switch to the Move tool.

▶ Change the foreground and background colors.
Double-click on the Gradient Tool. ❷

 Style: Foreground to Background Type: Linear Mode: Color
 Opacity: 40% Dither Transparency
Create a gradient by dragging from one side of the selection to the other.

▶ Create the remaining vertical and horizontal stripes in the same manner, but use
different colors for the gradients.

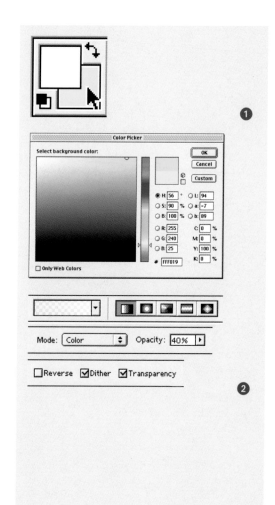

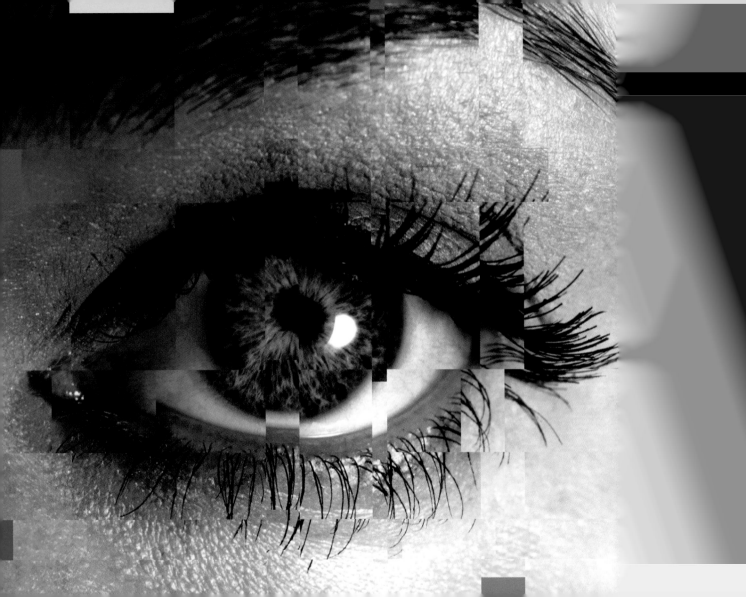

Drawing Techniques

Practically every drawing and painting technique can be simulated on the computer. Various software filters play a large role in creating the illustrated presentation techniques, and new drawing and painting techniques can give an image impact and distinction.

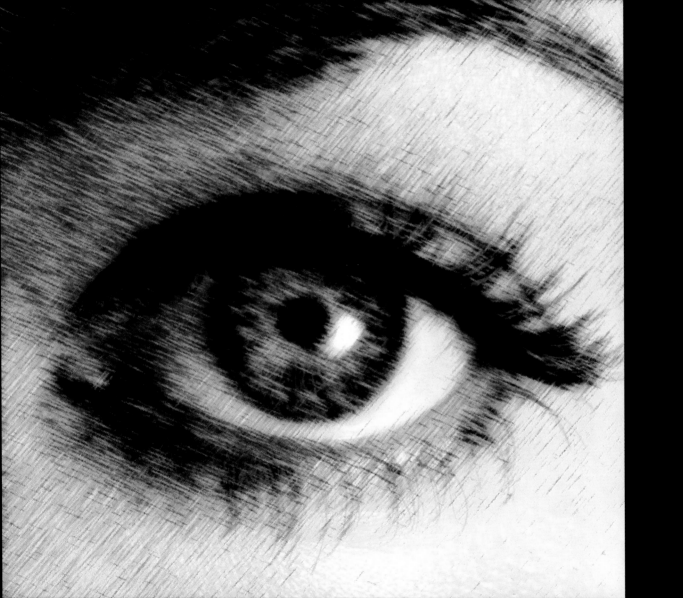

Shredding

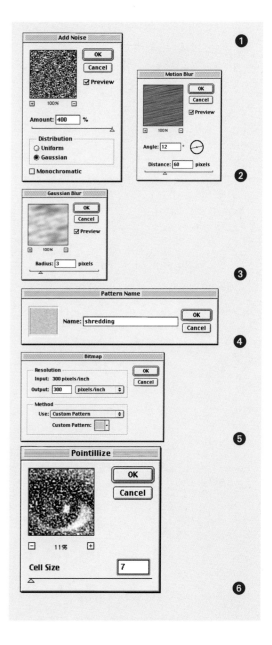

▶ Open the original halftone in Photoshop (**⌘O** or **File**).

▶ Show the Channels palette (**Window**). Create a new channel.

▶ Apply the following filters in this order:
Add Noise (**Filter>Noise**) ❶
 Amount: 400 Distribution: Gaussian
Motion Blur (**Filter>Blur**) ❷
 Angle: 12° Distance: 60 pixels
Find Edges (**Filter>Stylize**)
Gaussian Blur (**Filter>Blur**) ❸
 Radius: 3 pixels

▶ Select All (**⌘A** or **Select**).
Choose the Define Pattern command (**Edit**). ❹

▶ Target the Gray channel of the original image.
Select the Bitmap mode option (**Image>Mode**). ❺
 Output: 300 pixels/inch Method: Custom Pattern

▶ *Page 163: **Colored Pencil Texture***
*Open the original halftone in Photoshop (**⌘O** or **File**).*
*Select the RGB mode option (**Image>Mode**).*
*Show the Channels palette (**Window**).*
Target the Red Channel.
Apply the following filters:
*Pointillize (**Filter>Pixelate**) ❻*
 Cell size: 7
*Motion Blur (**Filter>Blur**)*
 Angle: 12° Distance: 60 pixels
*Sharpen More (**Filter>Sharpen**)*
Repeat the same filter sequence on the Green channel.
Enter a different angle in the Motion Blur dialog box.
Target the whole image in the RGB channel.
*Apply the Diffuse filter (**Filter>Stylize**).*
 Mode: Normal

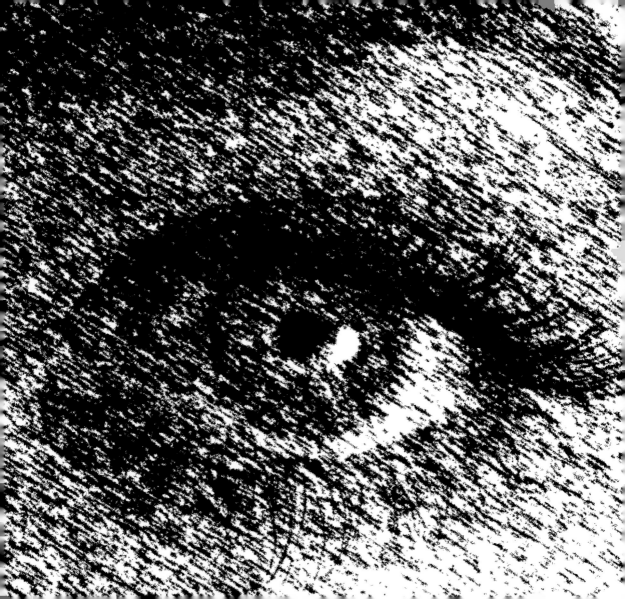

Wood Carving

▶ Open the original halftone in Photoshop (**⌘O** or **File**).

▶ Apply the Gaussian Blur filter (**Filter>Blur**). ❶
 Radius: 3 pixels

▶ Apply the Find Edges filter (**Filter>Stylize**).

▶ Open the Brightness/Contrast dialog box (**Image>Adjust**). ❷
 Brightness: 3 Contrast: 100

▶ Select the Bitmap mode option (**Image>Mode**). ❸
 Output: 300 pixels/inch Method: 50% Threshold

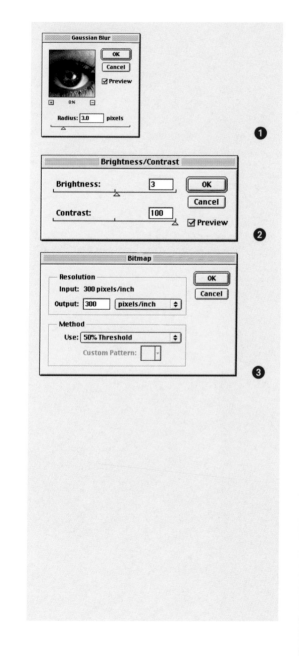

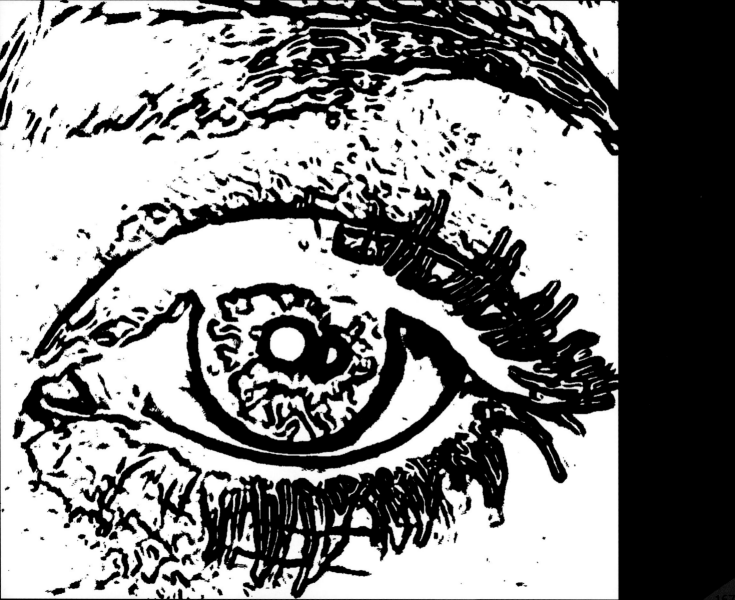

Photocopied Effect

▶ Open the original halftone in Photoshop (⌘**O** or **File**).

▶ Apply the High Pass filter (**Filter>Other**).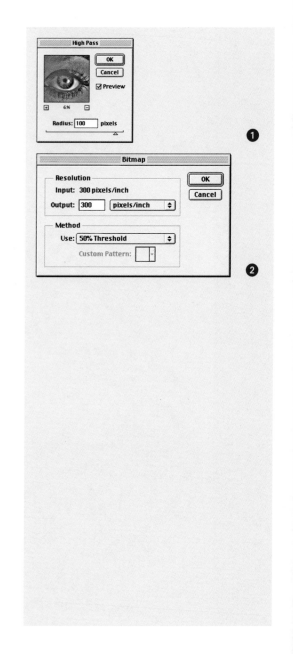
 Radius: 100 pixels

▶ Apply the Sharpen More filter (**Filter>Sharpen**).

▶ Select the Bitmap mode option (**Image>Mode**).
 Output: 300 pixels/inch Method: 50% Threshold

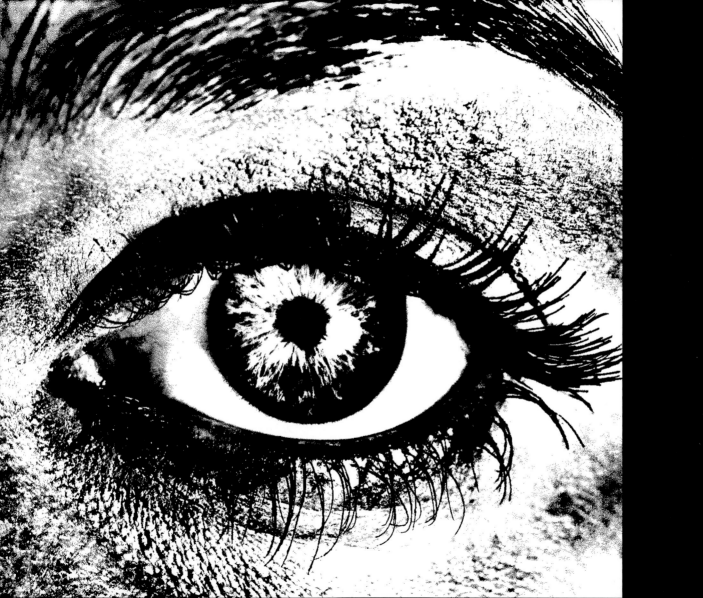

Pastels

▶ Open the original halftone in Photoshop (**⌘O** or **File**).

▶ Open the Brightness/Contrast dialog box (**Image>Adjust**). ❶
 Brightness: 50 Contrast: 95

▶ Use Color Range to select all the black in the image (**Select**). ❷
 With the Eyedropper tool, click on a black area in the preview window
 or in the image.
 Select Sampled Colors Fuzziness: 40 Select Image

▶ Use Save Selection to save selected areas to a new channel (**Select**).

▶ Select the RGB mode option (**Image>Mode**).

▶ Click on the Foreground Color swatch and select a color within the Color Picker.
 A shade of brown was used for the example.

▶ Select All (**⌘A** or **Select**).
 Apply a fill (**Edit**). ❸
 Use: Foreground Color
 Mode: Normal
 Opacity: 100%

▶ Load the selection of the channel you created as a New Selection. ❹

▶ Double-click on the Paintbrush tool. ❺
 Paint Mode: Dissolve Opacity: 70%
 Use various brush intensities, foreground colors, paint tools (such as the Airbrush
 and Pencil), and opacity settings to create a chalk pastel effect over the image.

▶ Delete the selection.

▶ Add final brush strokes across the image.

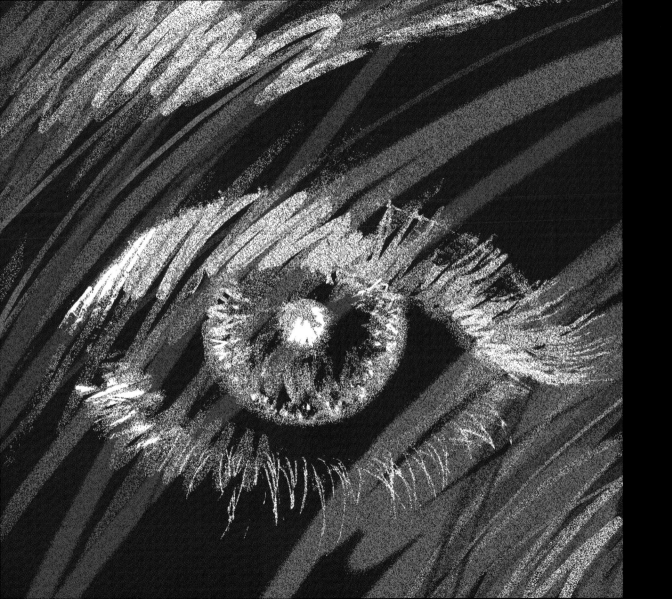

Sepia

▶ Create an RGB scan of a coarse piece of watercolor paper. Make the file the same size and resolution as the original halftone. Open the scan in Photoshop (⌘O or **File**).

▶ Open the original halftone in Photoshop (⌘O or **File**).

▶ Select the RGB mode option (**Image>Mode**).

▶ Select All (⌘A or **Select**), and copy (⌘C or **Edit**) the image.

▶ Target the watercolor paper image. Show the Channels palette (**Window**). Create a new channel. Paste the copied image into the channel (⌘V or **Edit**).

▶ Open the Brightness/Contrast dialog box (**Image>Adjust**). ❶
　Brightness: 50　　Contrast: 95

▶ Apply the Minimum filter (**Filter>Other**). ❷
　Radius: 6 pixels
　Apply the Gaussian Blur filter (**Filter>Blur**). ❸
　Radius: 6 pixels

▶ Open the Levels dialog box (⌘L or **Image>Adjust**). ❹
　Input Levels: Black: 36　　Gamma (midtone): 1.00　　White: 45

▶ Invert the image (⌘I or **Image>Adjust**).

▶ Target the RGB channel. Use the Load Selection command to load the saved selection (**Select**).

▶ Open the Levels dialog box (⌘L or **Image>Adjust**). ❺
　Input Levels: Black: 176　　Gamma (midtone): 1.00　　White: 255

▶ Tint the image with brown, orange, and violet tones:
　Double-click the Airbrush tool. ❻
　　Mode: Color　　Pressure: 14%
　Select an appropriate brush size. Define a foreground color for each pass.

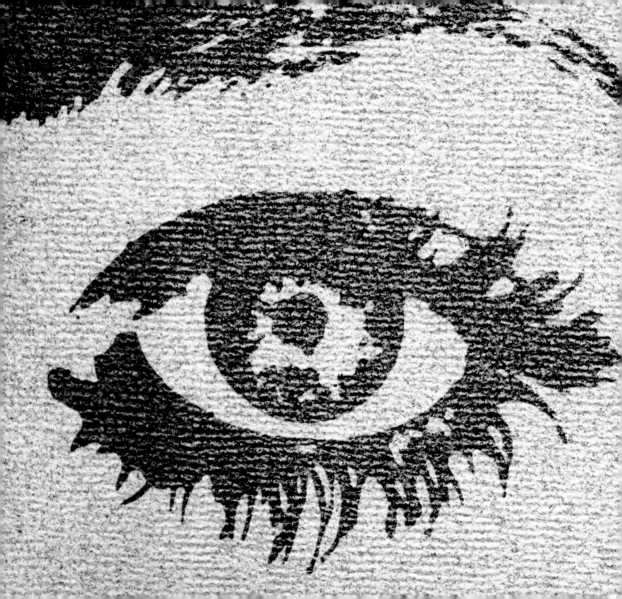

India Ink

▶ Open the original halftone in Photoshop (**⌘O** or **File**).

▶ Open the Threshold dialog box (**Image>Adjust**). ❶
Threshold Level: 50

▶ Apply the Minimum filter (**Filter>Other**).
Radius: 6 pixels
Apply the Gaussian Blur filter (**Filter>Blur**).
Radius: 6 pixels

▶ Open the Levels dialog box (**⌘L** or **Image>Adjust**). ❷
Increase the black Input Levels and decrease the white Input Levels.
Input Levels: Black: 60 Gamma (midtone): 1.00 White: 200

▶ Select All (**⌘A** or **Select**), and copy (**⌘C** or **Edit**) the image.

▶ Open the Channels palette (**Window**). Create a new channel.
Paste the copied image into the channel (**⌘V** or **Edit**).

▶ Apply the Maximum filter (**Filter>Other**). ❸
Radius: 10 pixels

▶ Target the Gray channel.
Apply the Minimum filter (**Filter>Other**).
Radius: 6 pixels

▶ Invert the image (**⌘I** or **Image>Adjust**).

▶ Combine the two channels:
Open the Calculations dialog box (**Image**).
Source 1: Gray channel Source 2: Alpha 1
Blending: Difference Opacity: 100% Result: New Channel

▶ Apply the Diffuse filter (**Filter>Stylize**). ❹
Mode: Normal
Apply a second time.
Shortcut: ⌘F reapplies the last filter.

▶ Select the Bitmap mode option (**Image>Mode**). ❺
Output: 300 pixels/inch Method: 50% Threshold

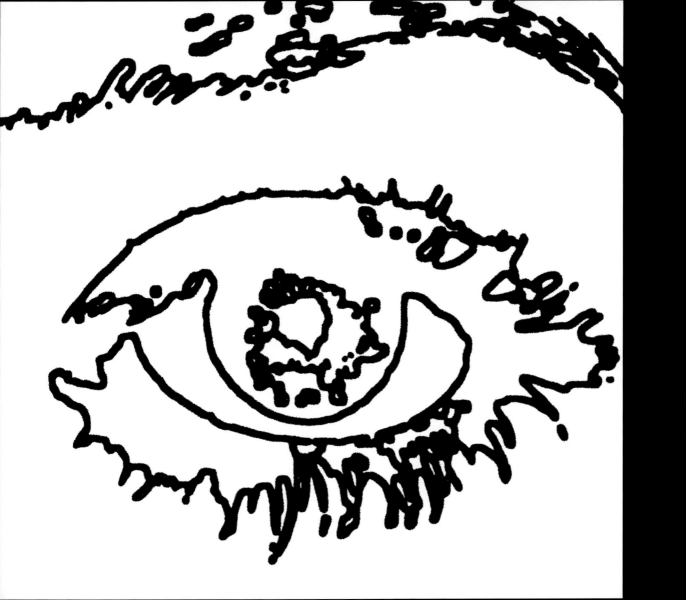

Stipple Technique

▶ Open the original halftone in Photoshop (⌘O or **File**).

▶ Open the Image Size dialog box (**Image**). ❶
Select Constrain Proportions
Select Resample Image: Bicubic
Resolution: 50 pixels/inch

▶ Apply the Gaussian Blur filter (**Filter>Blur**). ❷
Radius: 2 pixels

▶ Open the Posterize dialog box (**Image>Adjust**).
Levels: 5

▶ Apply the Diffuse filter four times (**Filter>Stylize**). ❸
Mode: Normal
Shortcut: ⌘F reapplies the last filter.

▶ Apply the Add Noise filter (**Filter>Noise**). ❹
Amount: 2 percent Distribution: Gaussian

▶ Open the Image Size dialog box (**Image**).
Select Constrain Proportions
Resolution: 220 pixels/inch

▶ Apply the Diffuse filter five times (**Filter>Stylize**). ❸
Mode: Normal
Shortcut: ⌘F reapplies the last filter.

▶ Open the Posterize dialog box (**Image>Adjust**).
Levels: 5

▶ Select the Indexed Colors mode (**Image>Mode**).

▶ Open the Color Table dialog box (**Image>Mode**). ❺
Table: Grayscale
Select a group of squares (values) from two of the tonal values. Choose colors from the Color Picker.

▶ Repeat the procedure for all remaining gray levels.

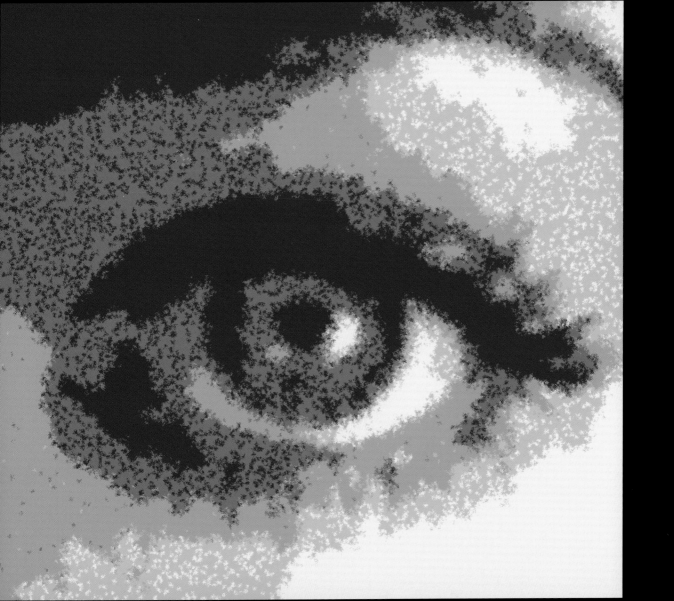

Color Foils

▶ Open the original halftone in Photoshop (**⌘O** or **File**).

▶ Apply the Gaussian Blur filter (**Filter>Blur**). ❶
 Radius: 6 pixels

▶ Open the Posterize dialog box (**Image>Adjust**). ❷
 Levels: 7

▶ Select the Indexed Colors mode (**Image>Mode**).

▶ Open the Color Table dialog box (**Image>Mode**). ❸
 Table: Grayscale
 Select a group of squares (values) from two of the tonal values.
 Choose colors from the Color Picker.

▶ Repeat the Open the Color Table dialog box procedure above
 for all remaining gray levels.

▶ *Page 180:* **Watercolor**
 Open the original halftone in Photoshop (⌘O or File).
 *Apply the Watercolor filter (***Filter>Artistic***). ❹*
 *Select the Indexed Colors mode (***Image>Mode***).*
 *Colorize the image using the Color Table (***Image>Mode***).*

▶ *Page 181:* **Oil**
 Open the original halftone in Photoshop (⌘O or File).
 Double-click on the Art History Brush tool. ❺
 Mode: Normal Opacity: 100% Style: Tight Short
 Fidelity: 14% Area: 100 pixels
 *Click and drag to apply "brushstrokes." You can use other tools, such as the Smudge and Blur tools,
 to duplicate the example.*
 *Select the Indexed Colors mode (***Image>Mode***).*
 *Colorize the image using the Color Table (***Image>Mode***). ❸*
 Rework the color transitions with the Rubber Stamp tool.

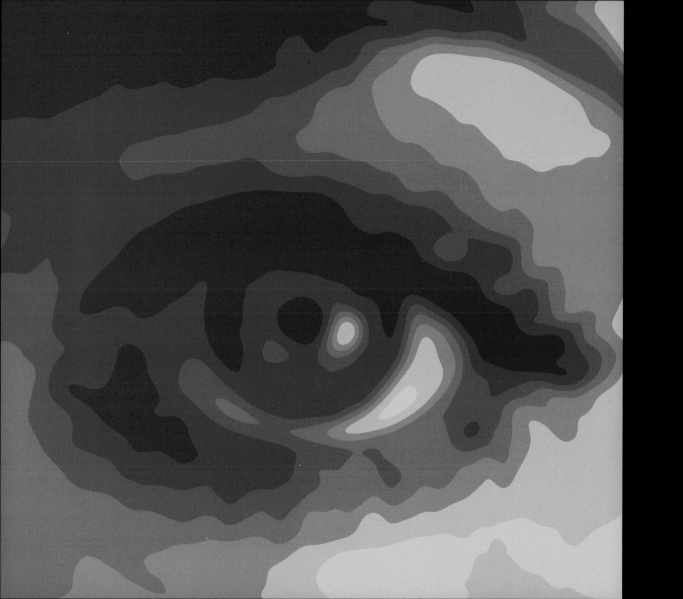

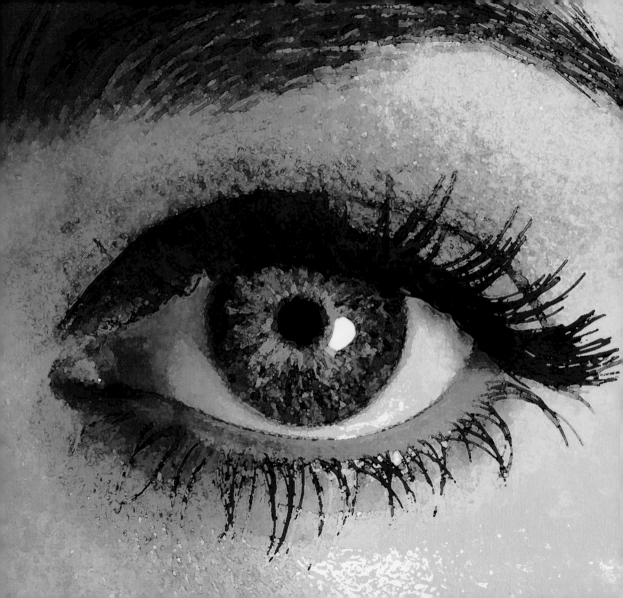

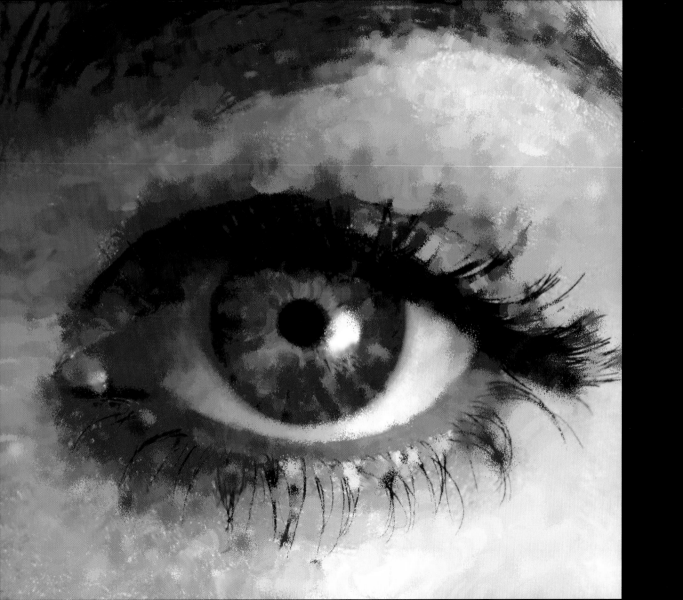

Airbrush

▶ Open the original halftone in Photoshop (**⌘O** or **File**).

▶ Open the Brightness/Contrast dialog box (**Image>Adjust**). **❶**
 Brightness: 65 Contrast: 100

▶ Select All (**⌘A** or **Select**), and cut (**⌘X** or **Edit**) the image.

▶ Show the Channels palette (**Window**). **❷**
 Create a new channel. Paste the copied image into the channel (**⌘V** or **Edit**).

▶ Invert the image (**⌘I** or **Image>Adjust**).

▶ Target the Gray channel. Set the foreground and background default colors (**D**).

▶ Double-click on the Gradient tool in the Tool palette. **❸**
 Style: Foreground to Background Type: Linear Mode: Color
 Opacity: 100% Dither Transparency
 Click at the bottom of the image and drag to the top.

▶ Use the Load Selection command to load the saved selection (**Select**). **❹**

▶ With the Gradient tool, click at the top of the image and drag to the bottom.

▶ Drop the selection (**⌘D** or **Select**).

▶ Select the CMYK mode option (**Mode**).

▶ Open the Hue/Saturation dialog box (**⌘U** or **Image>Adjust**).
 Select Colorize and use the sliders to adjust the image.
 Hue: –146 Saturation: 55 Lightness: 0

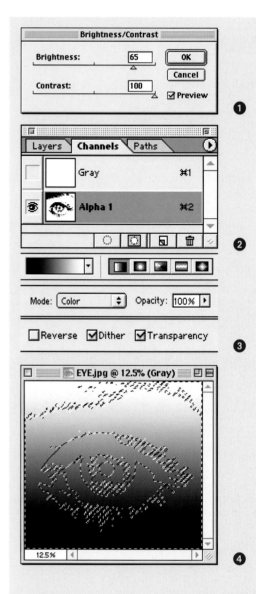

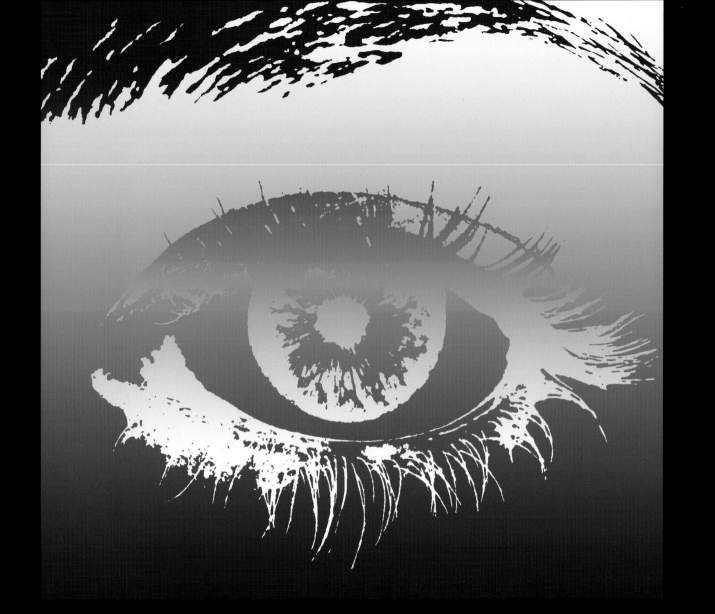

Silk-Screened Effect

▶ Trace a rough outline of the original image on a sheet of tracing paper. Scan the tracing in black and white. Make the file the same size and resolution as the original halftone.

▶ Open the scan in Photoshop (⌘O or **File**).

▶ Select All (⌘A or **Select**), and copy (⌘C or **Edit**) the image.

▶ Open the original halftone in Photoshop (⌘O or **File**). Select the RGB mode option (**Image>Mode**). Show the Layers palette (**Window**). Create a new layer; name it "Outline." Paste the copied image into the layer (⌘U or **Edit**).

▶ Use Color Range to select all the white in the image (**Select**). ❶
With the Eyedropper tool, click on any white area in the preview window or in the image.
 Select: Sampled Colors Fuzziness: 10 Image
Delete the selection. *This will rid the scan of its white background, leaving it transparent.*

▶ Drop the selection (⌘D or **Select**).

▶ Target the Background layer. Open the Brightness/Contrast dialog box (**Image>Adjust**). ❷
 Brightness: 0 Contrast: 95
Open the Hue/Saturation dialog box (⌘U or **Image>Adjust**). Select Colorize.
 Hue: 304 Saturation: 32 Lightness: −24

▶ Target the Outline layer. Check Lock. Pick a red foreground color and a yellow background color. Double-click on the Gradient tool. ❸
 Style: Foreground to Background Type: Linear Mode: Normal
 Opacity: 100% Dither Transparency
Drag the Gradient tool diagonally across the image.

▶ Use the Move tool to offset the Outline layer.

▶ Create a new layer; name it "Layer 1." Pick a new foreground color. Use the Lasso tool to select two areas. Fill the selections (**Edit**).

▶ Change the order of the layers:
Select "Layer 1" on the Layers palette. Drag it underneath the Outline layer. ❹

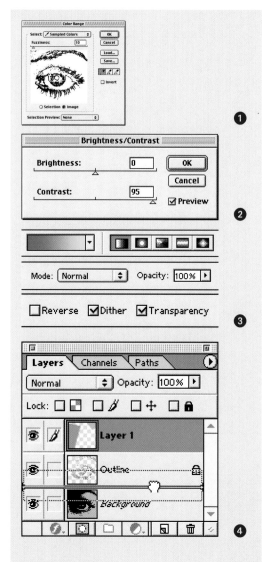

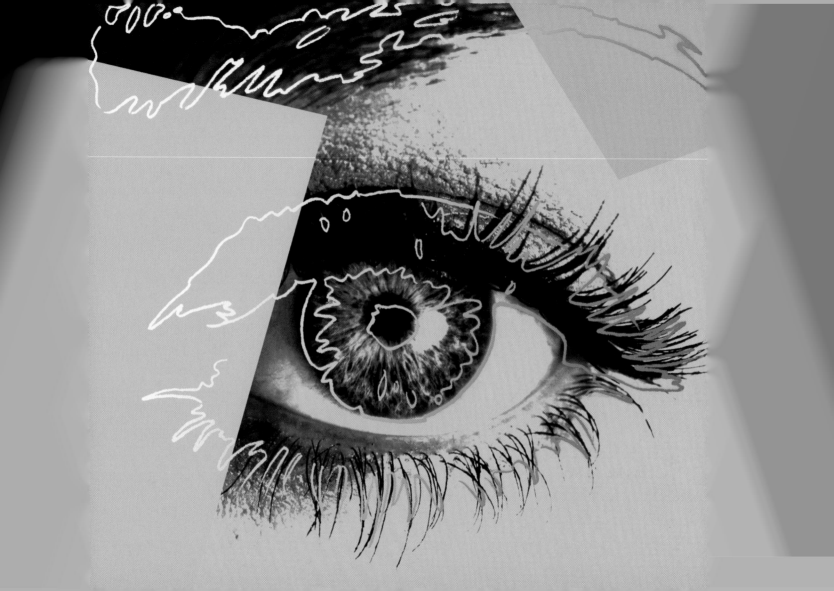

Illustrations

The boundary between photography and illustration is increasingly subtle, while illustrative options using digital image manipulation have become boundless. To create these examples, the degree of abstraction was restricted to maintain the size and likeness of the original photographic image.

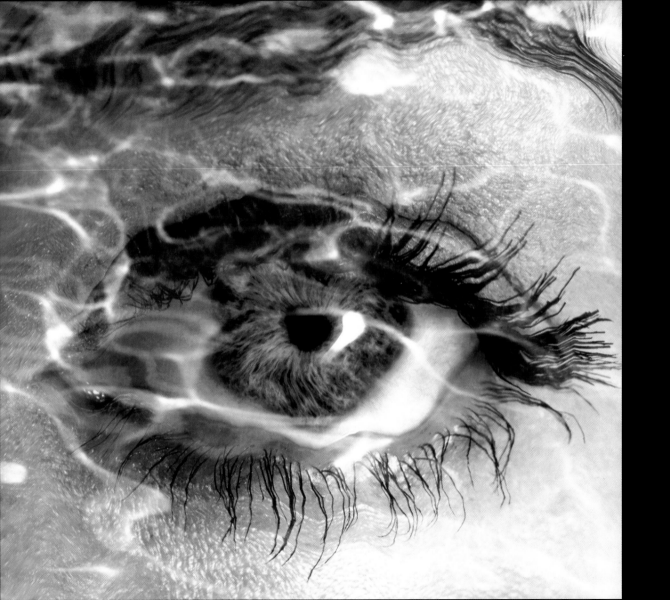

Patchwork

▶ Open the original halftone in Photoshop (⌘O or **File**).

▶ Use the Rectangular Marquee tool to select several sections of the image.

▶ Open the Levels dialog box (⌘L or **Image>Adjust**). Apply distinctive modifications to the brightness, contrast, and tonal range in each selection.

▶ Select the CMYK mode option (**Image>Mode**).

▶ Use the Rectangular Marquee tool to select another section.

▶ Open the Hue/Saturation dialog box (⌘U or **Image>Adjust**). ❶
Select Colorize.
 Hue: 353 Saturation: 88 Lightness: –7

▶ Invert the selection (**Select**).

▶ Open the Hue/Saturation dialog box (⌘U or **Image>Adjust**). ❷
Select Colorize.
 Hue: 180 Saturation: 30 Lightness: 0

▶ *Page 187:* ***Reflection in Water***
Scan an image of reflecting water in black and white. Make the file the same size and resolution as the original halftone. Open the scan in Photoshop (⌘O or **File***). Open the original halftone in Photoshop (⌘O or* **File***).*
*Apply the Wave filter (***Filter>Distort***).* ❸
 Number of Generators: 4
 Wavelength: Minimum 1, Maximum 330
 Amplitude: Minimum 1, Maximum 55
 Scale: Horizontal 100%, Vertical 100%
 Type: Triangle Undefined Areas: Repeat Edge Pixels
Select All (⌘A or **Select***), and copy (⌘C or* **Edit***) the image. Target the water image. Show the Layers palette (Window). Paste the image in the Clipboard, creating a new layer (⌘V or* **Edit***). Set the layer's blending mode to Overlay.* ❹
*Flatten the image (***Layer***). Select the CMYK mode option (***Image>Mode***). Open the Hue/Saturation dialog box (⌘U or* **Image>Adjust***). Select Colorize.* ❺
 Hue: 187 Saturation: 100 Lightness: 0

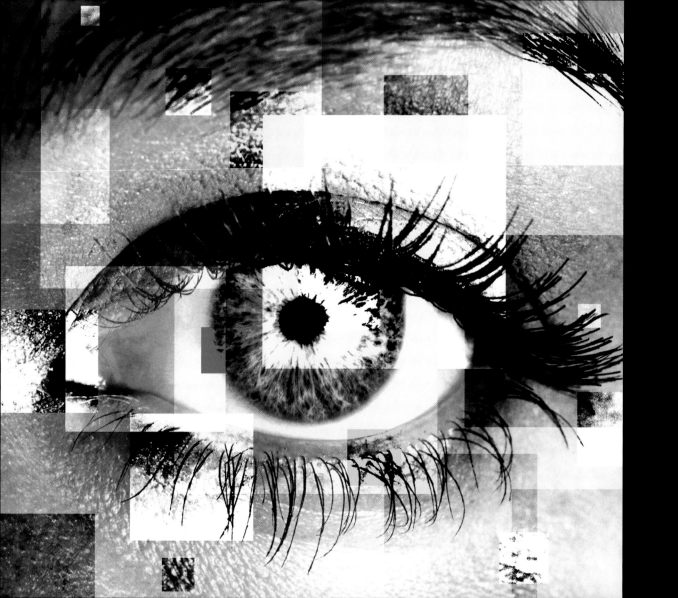

Checkerboard Pattern

▶ Open the original halftone in Photoshop (**⌘O** or **File**).

▶ Show the Channels palette (**Window**).
Create a new channel; name it "Checkerboard."

▶ Check the image size (**Image**). ❶
Divide the height of the image in pixels (1831) by 18, then round up to the nearest whole number (in this case, 102).

▶ In the Guides & Grid preferences, set the gridlines to appear every 102 pixels (**Edit>Preferences**). ❷
Use the number you obtained in the previous step.

▶ Build a checkerboard pattern in the channel:
Show the grid (**View>Show**). Select the Rectangular Marquee tool in the Tool palette and drag to select the first square in the grid. Shift-drag to select every other square in the first row. Fill the selected squares with white (**Edit**).

▶ Double-click on the Rectangular Marquee tool in the Tool palette and choose Fixed Size from the Style menu. ❸
 Width: 3000 Height: 102
Click to select the first row of squares. Switch to the Move tool (**V**) and Option-drag to copy the first row of squares to every other row. Then Option-drag to copy the selected squares to the first blank row, moving it over one square to the right. Option-drag to copy the squares to every other row to complete the checkerboard pattern. Drop the selection (**⌘D** or **Select**).

▶ Apply the Spherize filter (**Filter>Distort**). ❹
 Amount: 100% Mode: Normal
Return to the Gray channel.

▶ Select the CMYK mode option (**Image>Mode**).

▶ Use Load Selection to load the saved selection "Checkerboard" (**Select**).

▶ Open the Hue/Saturation dialog box (**⌘U** or **Image>Adjust**). ❺
Select Colorize and use the sliders to adjust the image.
 Hue: 191 Saturation: 78 Lightness: −30

▶ Invert the selection (**Select**).

▶ Open the Hue/Saturation dialog box (**⌘U** or **Image>Adjust**). ❻
Select Colorize and use the sliders to adjust the image.
 Hue: 340 Saturation: 85 Lightness: −30

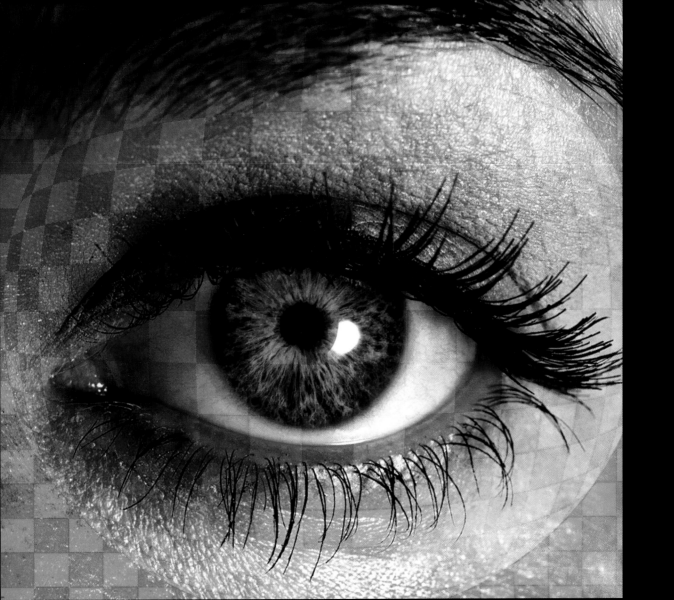

Foliage

▶ Open the original halftone in Photoshop (**⌘O** or **File**).

▶ Scan an image of foliage in black and white. Make sure this file is the same size and resolution as the original halftone.

▶ Select the Move tool (**V**). Drag the scanned image into the original halftone window.

▶ In the original image, show the Layers palette (**Window**). Double-click on the foliage layer thumbnail to open the Layer Style dialog box. Adjust the Composite Controls. **1**

▶ Click the Add Layer Mask on the Layers palette.

▶ Use the Lasso tool to select an area (in our case, the eyeball). Feather the selection (**Select**). **2**
 Radius: 30 pixels

▶ Apply a fill (**Edit**).
 Shortcut: **Shift Delete** *brings up the Fill dialog box.* **3**
 Use: Black Opacity: 100% Mode: Normal

▶ Flatten the image (**Layer**).

▶ Select the CMYK mode option (**Image>Mode**).
 Open the Hue/Saturation dialog box (**⌘U** or **Image>Adjust**). **4**
 Select Colorize and use the sliders to adjust the image.
 Hue: 60 Saturation: 50 Lightness: 0

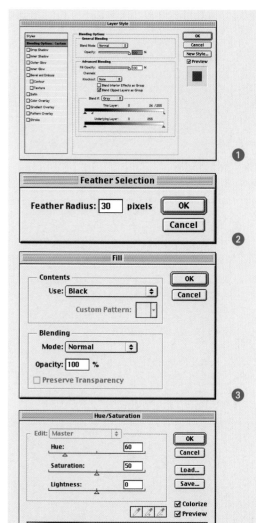

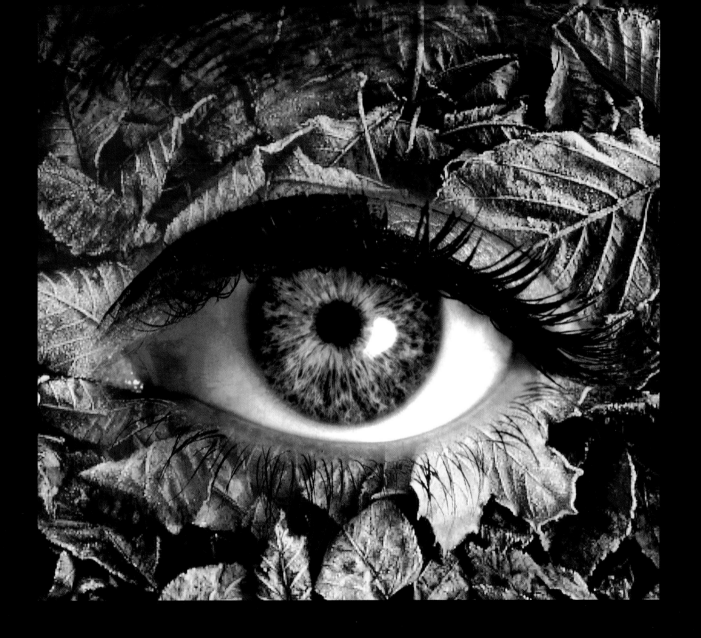

Combining Subjects

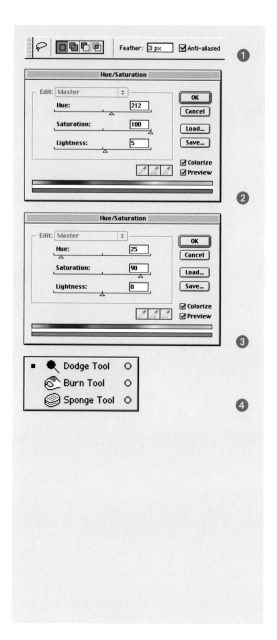

▶ Scan an image of water in black and white. Make sure this file is the same size and resolution as the original halftone.

▶ Open the scan in Photoshop (**⌘O** or **File**). Select All (**⌘A** or **Select**), and copy (**⌘C** or **Edit**) the image.

▶ Open the original halftone in Photoshop (**⌘O** or **File**).

▶ Double-click the Lasso tool. ❶
 Feather: 3 pixels Anti-aliased
Select an area to paste into (in our example, the eyeball).

▶ Save the selection (**Select**).

▶ Apply the Paste Into command (**Edit**).

▶ Select the CMYK mode option (**Image>Mode**).

▶ Open the Hue/Saturation dialog box (**⌘U** or **Image>Adjust**). ❷
 Select Colorize and use the sliders to adjust the image.
 Hue: 212 Saturation: 100 Lightness: 5

▶ Target the Background layer in the Layers palette.

▶ Open the Hue/Saturation dialog box (**⌘U** or **Image>Adjust**). ❸
 Select Colorize and use the sliders to adjust the image.
 Hue: 25 Saturation: 90 Lightness: 0

▶ Invert the selection (**Select**).

▶ Use the Dodge and Burn tools to strengthen the water effect. ❹
 Shortcut: **Shift O** *toggles among the three toning tools: Dodge, Burn, and Sponge.*

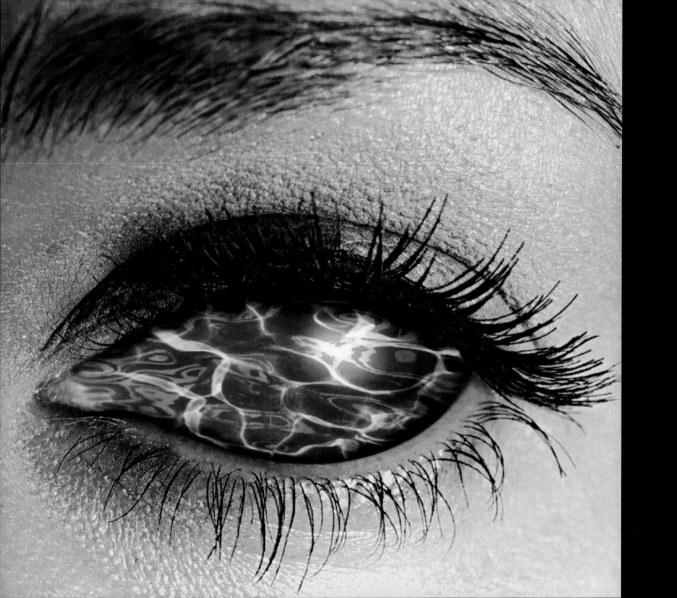

Gelatin Effect

▶ Open the original halftone in Photoshop (**⌘O** or **File**). Open the Brightness/Contrast dialog box (**Image>Adjust**). ①
 Brightness: 65 Contrast: 100
 Apply the Gaussian Blur filter (**Filter>Blur**). ②
 Radius: 20 pixels

▶ Open the Brightness/Contrast dialog box (**Image>Adjust**).
 Brightness: 40 Contrast: 90
 Invert the image (**⌘I** or **Image>Adjust**).
 Duplicate the image (**Image**); name the duplicate "Image 1." ③

▶ Apply the Offset filter (**Filter>Other**).
 Horizontal: 12 Vertical: 8
 Undefined Areas: Repeat Edge Pixels

▶ Apply the Gaussian Blur filter (**Filter>Blur**).
 Radius: 8 pixels

▶ Open the Brightness/Contrast dialog box (**Image>Adjust**).
 Brightness: 0 Contrast: –50

▶ Save changes to Image 1 (**⌘S** or **File**). Duplicate Image 1 (**Image**); name the duplicate "Image 2."

▶ Apply the Offset filter (**Filter>Other**). ④
 Horizontal: –20 Vertical: –15
 Undefined Areas: Repeat Edge Pixels

▶ Save changes to Image 2 (**⌘S** or **File**). Combine Image 1 and Image 2. Open the Calculations dialog box (**Image**). ⑤
 Source 1: Image 2 Source 2: Image 1
 Blending: Difference Result: New Document

▶ Apply the Auto Levels command (**Image>Adjust**). Invert the image (**⌘I** or **Image>Adjust**). Save as "Image 3" (**File**).

▶ Combine Image 1 and Image 3. Open the Calculations dialog box (**Image**).
 Source 1: Image 1 Source 2: Image 3
 Blending: Difference Result: New Document

▶ Invert the image (**⌘I** or **Image>Adjust**).
 Apply the Auto Levels command (**Image>Adjust**).
 Select the Grayscale mode option (**Image>Mode**).
 Select the CMYK mode option (**Image>Mode**).
 Open the Hue/Saturation dialog box (**⌘U** or **Image>Adjust**).
 Hue: 280 Saturation: 100 Brightness: 25

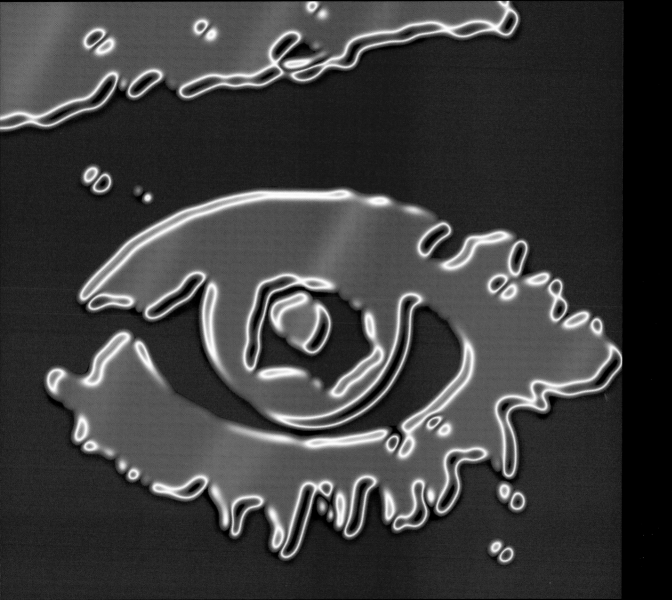

Metal Sign

▶ Open the original halftone in Photoshop (**⌘O** or **File**). Open the Brightness/Contrast dialog box (**Image>Adjust**).
 Brightness: 60 Contrast: 100
Apply the Gaussian Blur filter (**Filter>Blur**). **1**
 Radius: 25 pixels
Open the Levels dialog box (**⌘L** or **Image>Adjust**). Increase the black Input Levels and decrease the white Input Levels.

▶ Select All (**⌘A** or **Select**), and cut (**⌘X** or **Edit**) the image. Show the Channels palette (**Window**). **2**
Create a new channel; name it "Metal Mask." Paste the selection from the Clipboard (**⌘V** or **Edit**). Invert the image (**⌘I** or **Image>Adjust**).

▶ Target the Gray channel. Apply a fill (**Edit**).
Shortcut: **Shift Delete** *brings up the Fill dialog box.*
 Use: 50% Gray Opacity: 100% Mode: Normal

▶ Apply the following filters:
Add Noise (**Filter>Noise**)
 Amount: 400 Distribution: Gaussian
Gaussian Blur (**Filter>Blur**)
 Radius: 1 pixel
Facet (**Filter>Pixelate**) Blur More (**Filter>Blur**)

▶ Apply the Auto Levels command (**Image>Adjust**).
Apply the Emboss filter (**Filter>Stylize**). **3**
 Angle: 135° Height: 4 pixels Amount: 100%

▶ Target the Metal Mask channel. Select All (**⌘A** or **Select**), and copy (**⌘C** or **Edit**) the image. Create a new channel; name it "Channel 3." Paste the selection from the Clipboard (**⌘V** or **Edit**).
Apply the Gaussian Blur filter (**Filter>Blur**).
 Radius: 15 pixels
Apply the Offset filter (**Filter>Other**). **4**
 Horizontal: 40 Vertical: 40 Undefined Areas: Repeat Edge Pixels

▶ Target the Gray channel. Use the Load Selection command (**Select**). Load Channel 3. Open the Levels dialog box (**⌘L** or **Image>Adjust**). Adjust the Input Levels to darken or lighten the image as desired.

▶ Apply the Load Selection command (**Select**). Load Metal Mask. Use the Airbrush tool (**J**)to create glare. Select the CMYK mode option (**Image>Mode**). Open the Hue/Saturation dialog box and check Colorize (**⌘U** or **Image>Adjust**).
 Hue: 55 Saturation: 100 Lightness: 40

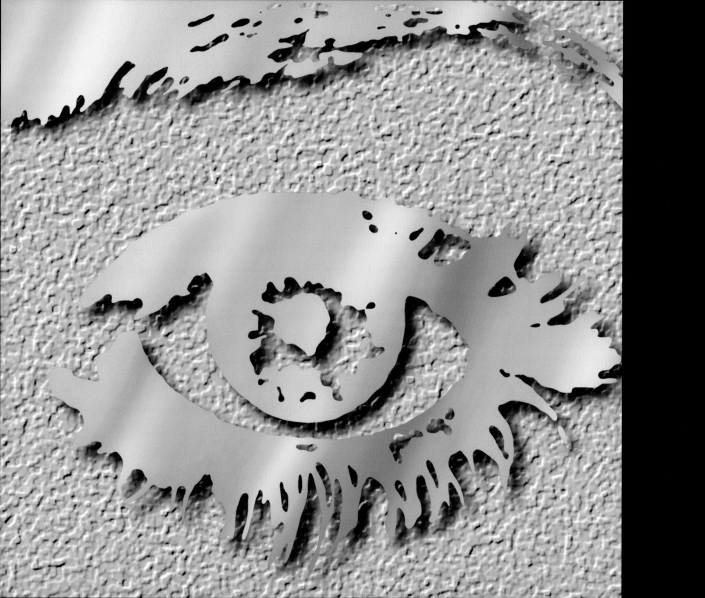

Neon

▶ Open the original halftone in Photoshop (⌘O or **File**). Select the CMYK mode option (**Image>Mode**).

▶ Open the Paths palette (**Window**). ❶
Create a new path; name it "Neon."

▶ Trace the image's outline using the Pen tool.

▶ Target the Background layer. Select All (⌘A or **Select**) and press **Delete**.

▶ Double-click the Airbrush tool (**J**). ❷
 Paint mode: Normal Pressure: 100% 35-pixel soft brush
Choose a custom color from the Color Picker.

▶ Target the Paths palette. Switch to the Path Component Selection Tool and select All (⌘A or **Select**). Choose Stroke Path from the Paths palette menu. ❸
 Tool: Airbrush
Press Delete to clear the selected paths.

▶ Select the Grayscale mode option (**Image>Mode**). Invert the image (⌘I or **Image>Adjust**).

▶ Select the Indexed Colors mode option (**Image>Mode**).
Open the Color Table dialog box (**Image>Mode**).
 Table: Custom
Select the top 4 rows of squares. From the Color Picker, choose black as the first color and magenta as the last color.

▶ Open the Color Table dialog box (**Image>Mode**).
 Table: Custom
Select the bottom 12 rows of squares. From the Color Picker, choose magenta as the first color and white as the last color.

▶ Select the CMYK mode option (**Image>Mode**).
In the Layers palette, duplicate the Background layer.
Target the new layer.
Apply the Gaussian Blur filter (**Filter>Blur**). ❹
 Radius: 40 pixels
Choose Overlay from the Blending mode pop-up menu in the Layers palette. ❺

▶ Open the Levels dialog box (⌘L or **Image>Adjust**). Experiment to enhance the tonal ranges of the image.

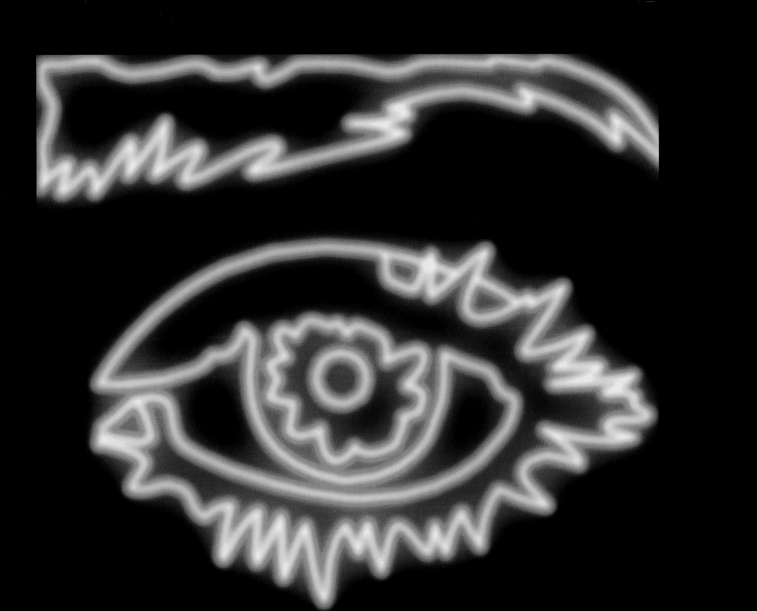

Glass Shards

▶ Open the original halftone in Photoshop (⌘O or **File**).

▶ Show the Channels palette. Create a new channel; name it "Black Background." ①
Make white the foreground color and select the Pencil tool (**B**). Choose a large hard
brush and draw the white cracks between the black glass shards.
With a pressure-sensitive tablet, choose Stylus from the Size pop-up menu in the Brush Dynamics
area of the Pencil Options bar. Then apply varying pressure to the stylus to vary the width of the
white cracks as you draw them.

▶ Duplicate the Black Background channel. Switch to the Move tool (**U**) and
nudge the duplicate channel down and to the left. Name the duplicate channel
"Light Edges."

▶ Target the Gray channel in the Channels palette.

▶ Load the selection of the Black Background channel (**Select**) and fill the selection
with black (**Edit**). ②

▶ Load the selection of the Light Edges channel (**Select**).
Use the Load Selection command to subtract the Black Background channel from
the selection (**Select**). ③
Fill the selection with white (**Edit**). ④
 Use: White Mode: Normal Opacity: 100%

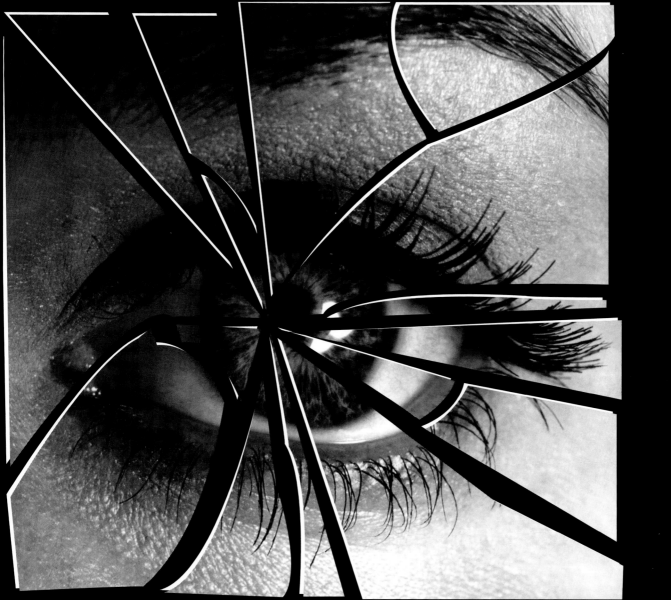

Fire

▶ Scan an image of fire in RGB mode; name it "Fire." Make the file the same size and resolution as the original halftone. Open the image "Fire" in Photoshop (⌘O or **File**).

▶ Select the Indexed Colors mode option (**Image>Mode**). Open the Color Table dialog box (**Image>Mode**). ❶
 Table: Custom
 Save the table as "Flames."

▶ Select the RGB mode option (**Image>Mode**).

▶ Open the original halftone in Photoshop (⌘O or **File**).

▶ Select the RGB mode option (**Image>Mode**).
 Select the Indexed Colors mode option (**Image>Mode**).
 Open the Color Table dialog box (**Image>Mode**).
 Load the Flames table.

▶ Select the Move tool and drag "Fire" onto the original halftone's document window. A new layer is generated containing the fire image. Name it "Fire."

▶ Target the Fire layer. Click the Add Layer Mask button on the Layers palette. Reset the foreground and background colors to the defaults (**D**).

▶ Double-click on the Gradient tool. ❷
 Style: Foreground to Background Type: Linear Mode: Darken
 Opacity: 100% Dither Transparency
 Create a vertical gradient by dragging from the top of the image to the bottom.

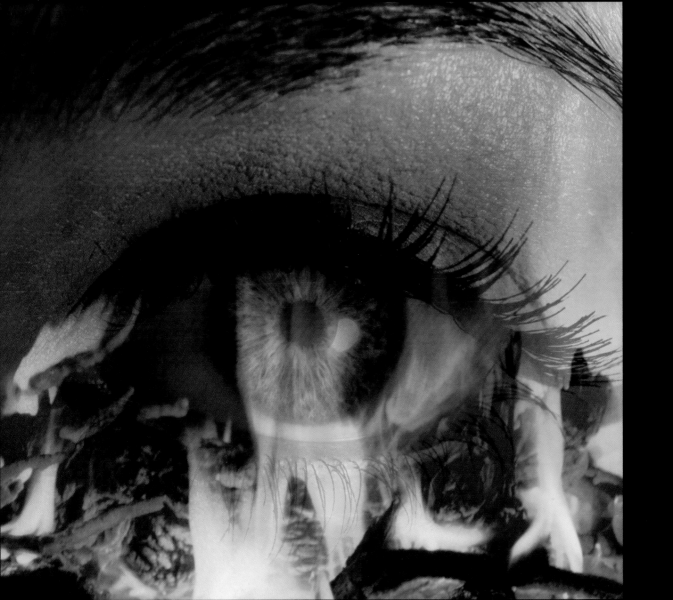

Cartoon

▶ Open the original halftone in Photoshop (⌘O or **File**). Select the RGB mode option (**Image>Mode**).

▶ Show the Paths palette. Select the Pen tool and trace the various shapes. **①**
They must be independently closed shapes.

▶ Choose a color in the Color palette. Select the Marquee tool (**M**). Select All (⌘A or **Select**), and fill the image with the foreground color (**Edit**). **②**
 Use: Foreground Color Mode: Normal Opacity: 100%

▶ Create a drop-shadow effect:
Select the Path Component Selection tool and select All (⌘A or **Edit**). Click the Convert Path to Selection button at the bottom of the Paths palette. **③**
Select the Marquee tool (**M**) and drag the selection down and to the right, then fill it with black.
 Use: Black Mode: Normal Opacity: 100%

▶ Fill the shapes with color:
Choose a color in the Color palette. Select the Path Component Selection tool and click on one of the path shapes. Click the Convert Path to Selection button at the bottom of the Paths palette and fill the selection (**Edit**).
 Use: Foreground Color Mode: Normal Opacity: 100%
Repeat for all the shapes.

▶ Color the lines black:
With the Path Component Selection tool active, select All (⌘A or **Select**). Reset the foreground and background colors to the defaults (**D**). Choose Stroke Path from the Paths palette menu. **④**

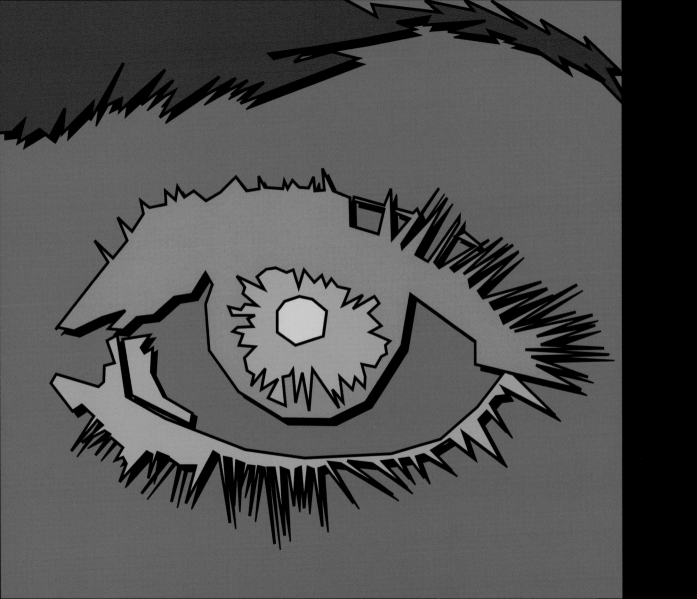

Overpainting

▶ Open the original halftone in Photoshop (⌘O or **File**).

▶ Show the Layers palette.

▶ Give the image a 40% tint: Double-click on the Background layer to turn it into a transparent layer. Set the layer's Opacity in the Layers palette to 40%, then flatten the image (**Layer**). **❶**

▶ Create a new layer. Open the Threshold dialog box (**Image>Adjust**).
Threshold Level: 40

▶ Select the Airbrush tool (**J**). **❷**
Mode: Overlay Pressure: 40%
Choose a large, soft brush and paint the image in soft colors. *Use creative license here.*

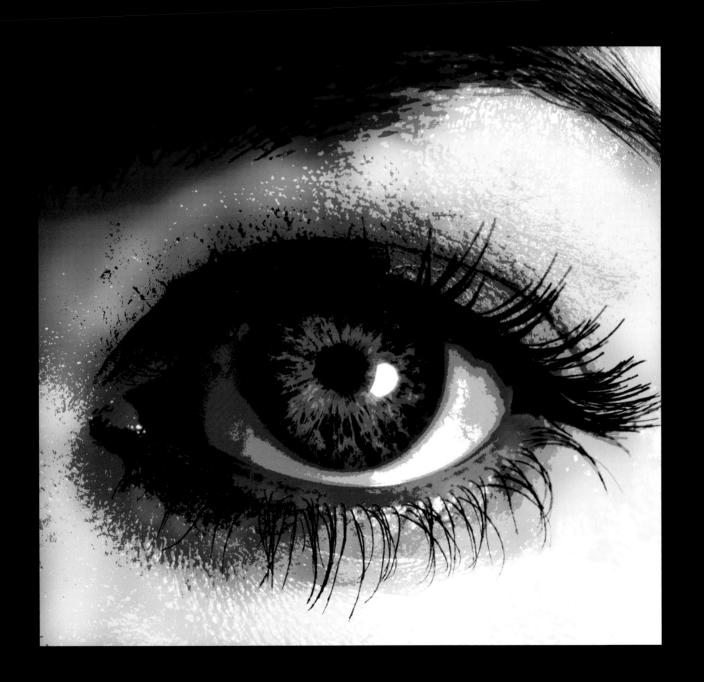

Clouds

▶ Scan an image of clouds in black and white; name it "Clouds." Make sure this file is the same size and resolution as the original halftone. Open the scan in Photoshop (**⌘O** or **File**).

▶ Open the original halftone in Photoshop (**⌘O** or **File**). Select the Move tool (**V**) and drag the image into the Clouds image window. A new layer is formed with the original image in it.

▶ Show the Layers palette (**Window**). Target the layer containing the original image. Click the Add Layer Mask button at the bottom of the Layers palette.

▶ Double-click the Lasso tool. **1**
 Feather: 20 pixels Anti-aliased
Select an area to be masked.

▶ Invert the selection (**Select**).

▶ Fill the selection with black (**Edit**). **2**
 Use: Black Mode: Normal Opacity: 100%
Shortcut: **Shift Delete** *brings up the Fill dialog box.*

▶ Drop the selection (**⌘D** or **Select**).

▶ Set the foreground and background colors to their defaults (**D**).

▶ Double-click the Airbrush tool. **3**
 Paint mode: Normal Pressure: 50%
Select a 65-pixel soft brush.
Use the Airbrush to add to the mask. If you need to subtract from the mask, switch the foreground and background colors (**X**) and paint away the mask.

▶ Select the CMYK mode option (**Image>Mode**).
Open the Hue/Saturation dialog box (**⌘U** or **Image>Adjust**). Click Colorize and adjust the sliders.
 Hue: –155 Saturation: 70 Lightness: 0

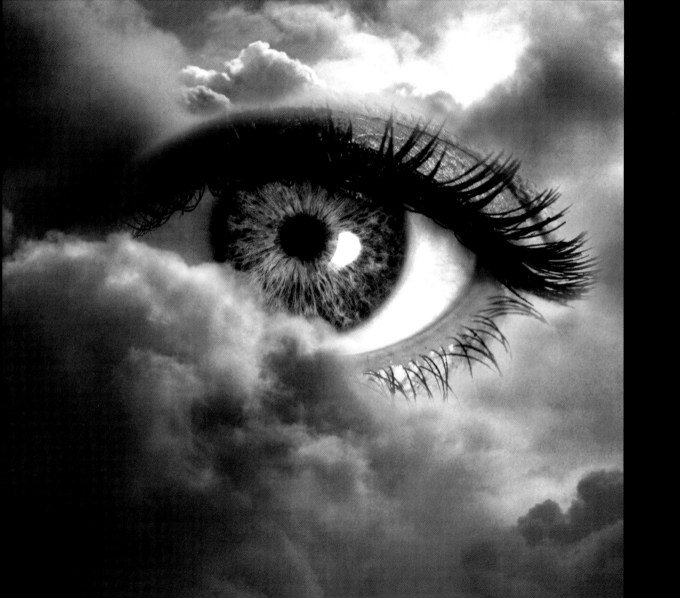

Color Swash

▶ Scan an image of a brush stroke in grayscale; name it "Swash." Make the file the same size and resolution as the original halftone. Open the scan in Photoshop (**⌘O** or **File**).

▶ Open the original halftone in Photoshop (**⌘O** or **File**).
Apply the Mosaic filter (**Filter>Pixelate**). ❶
 Cell Size: 35 pixels square
Select the CMYK mode option (**Image>Mode**).
Save the file as "Mosaic" (**File**).

▶ Activate the Swash file. Double-click the Magic Wand tool. ❷
 Tolerance: 0
Use the Magic Wand tool to select the black brush stroke.
Drag the selection to the Mosaic file. A new layer is created to hold the selection; rename the new layer "Swash."

▶ Open the original halftone in Photoshop (**⌘O** or **File**).
Select the Indexed Colors mode option (**Image>Mode**).
Open the Color Table dialog box (**Image>Mode**).
 Table: Spectrum
Select the CMYK mode option (**Image>Mode**).

▶ Select the Move tool (**V**) and drag the image into the Mosaic image window. ❸
A new layer is created to hold the selection; rename the new layer "Original."

▶ Create a clipping group: ❹
Option-click on the line between the Original layer and the Swash layer in the Layers palette.

▶ Target the Swash layer. Choose Duplicate Layer from the Layers palette menu.
Shortcut: Drag the layer thumbnail onto the New Layer button.

▶ Target the Swash layer. Select the Move tool (**V**). Click on the image and drag it slightly down and to the right to create a drop-shadow effect. The arrow keys can also be used to position it.

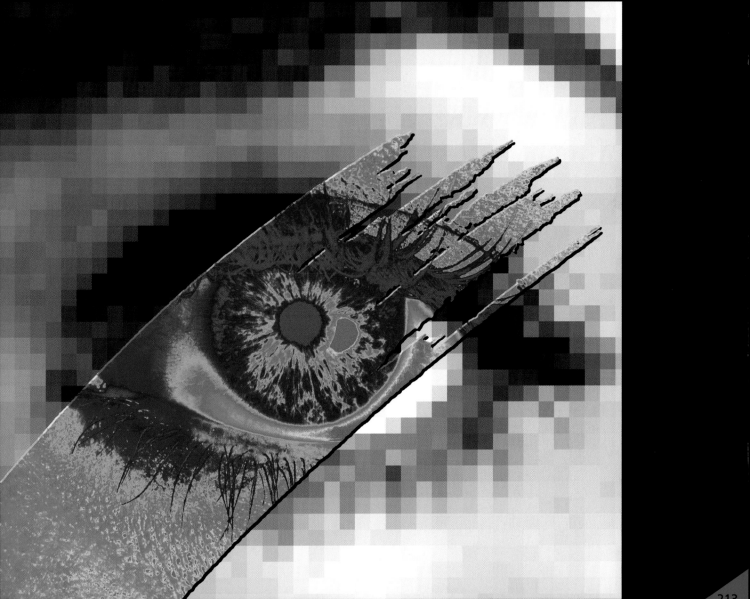

Pattern Fill

▶ Open the original halftone in Photoshop (⌘O or **File**).

▶ Select the CMYK mode option (**Image>Mode**).

▶ Create a Pattern Fill layer (**Layer>New Fill Layer>Pattern**). ❶
 Color: None Mode: Normal Opacity: 35%
 Select the Zebra pattern fill. ❷
 Scale: 941%

▶ Create a Solid Color Fill layer above the Pattern Fill layer.
 Color: None Mode: Normal Opacity: 31%
 Define the fill color as:
 C: 6% M: 99% Y: 100% K: 1%

▶ Create a New Adjustment layer (**Layer>New Adjustment Layer**).
 Shortcut: Click on the ◑ symbol at the bottom of the Layers palette to display the Layer options menu.
 Choose the Gradient Map option. ❸
 Choose the Transparent Rainbow option. ❹

▶ *Page 216: High-Contrast Color Fill*
 Open the original halftone in Photoshop (⌘O or File).
 Select the RGB mode option (Image>Mode).
 Duplicate the Background layer (Layer); name it "Background 1."
 Open the Brightness/Contrast dialog box (Image>Adjust). ❺
 Brightness: 62 Contrast: 100
 Create a new layer (Layer>New); position it under Background 1.
 Using various Paint tools, apply color as desired. ❻
 Apply the Gaussian Blur filter (Filter>Blur). ❼
 Radius: 55 pixels
 Select the Background 1 layer.
 Choose the Layer Blending mode: Screen. ❽

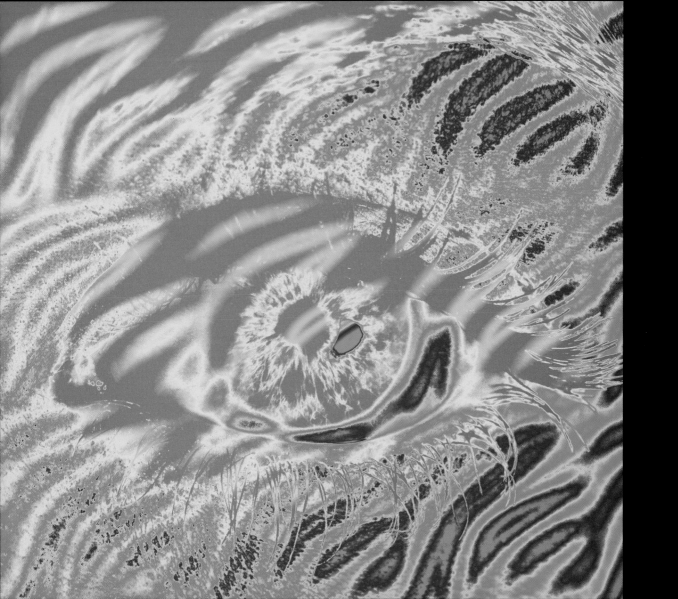

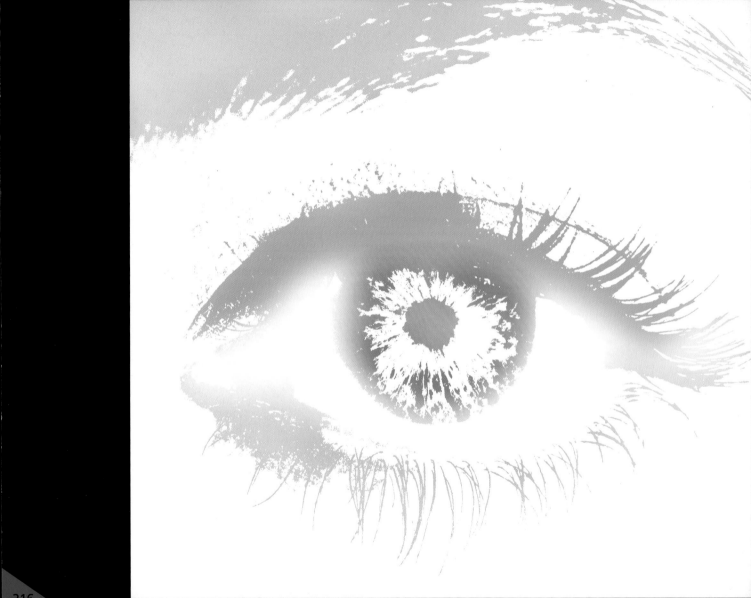